RECREATING AN AGE OF REPTILES

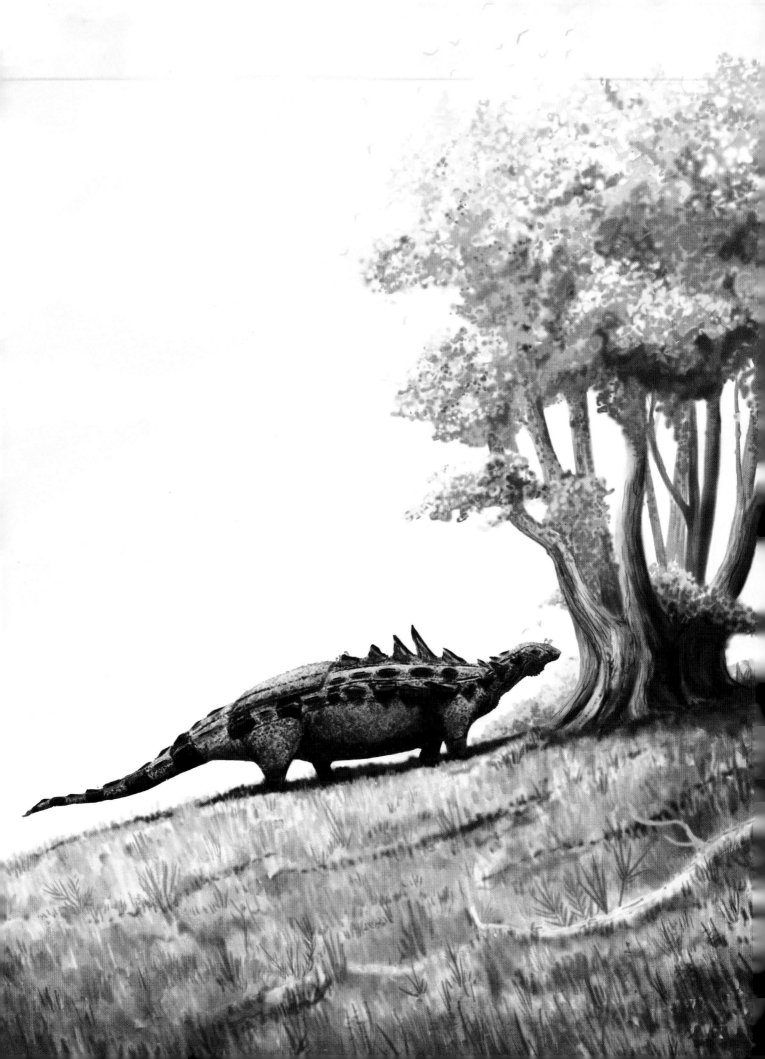

RECREATING AN AGE OF REPTILES

Mark P. Witton

THE CROWOOD PRESS

First published in 2017 by
The Crowood Press Ltd
Ramsbury, Marlborough
Wiltshire SN8 2HR

www.crowood.com

© Mark Witton 2017

All rights reserved. No part of this publication may be reproduced or transmitted in any form or by any means, electronic or mechanical, including photocopy, recording, or any information storage and retrieval system, without permission in writing from the publishers.

British Library Cataloguing-in-Publication Data
A catalogue record for this book is available from the British Library.

ISBN 978 1 78500 334 9

Frontispiece: Attempts to browse by the ankylosaurid *Polacanthus foxii* are interrupted by avian ruffians. Early Cretaceous (Barremian), UK. (2014, revised 2015)

This book is dedicated to my many pets.
Doof, a chicken; Walter, a skink; Mrs Hawking, a chicken; Hogey, a python;
Verdigris, a gecko; Ringo, another chicken; and Georgia, a wife.

Printed and bound in India by Replika Press Pvt Ltd.

Contents

Acknowledgements	6
About the author and artist	6
Preface: How many ways can we reconstruct extinct animals	7
Careful now: we're only predatory dinosaurs	9
Of Mesozoic seas	18
Sauropods: the (second) best animals	24
The Mesozoic was full of holes	30
A world of pterosaurs	35
Mesozoic synapsids: coming of age	46
Rethinking *Dimorphodon*	50
River masters	56
Local heroes	62
Controversial ceratopsians	68
Hey Triassic, you so crazy	77
An accidental *Tyrannosaurus* fan	84
Those persistent azhdarchid pterosaurs	90
Postscript: All those moments will be lost in time	102
Index	109

Acknowledgements

All palaeoart is the end result of countless hours of research and investigation. Sometimes the process is a solo effort, but we mostly stand on the shoulders of other palaeontologists and artists to produce new work. Particular debts are owed to those talented individuals who produce painstakingly, carefully rendered skeletal reconstructions of fossil animals. These are invaluable references without which our art would be nowhere near as accurate or interesting. The pool of artists able to produce good skeletal restorations of extinct animals is growing, but dedicated shout outs are warranted for Scott Hartman and Gregory S. Paul. These individuals deserve huge accolade for not only their work on reconstructing fossil animal skeletons, but also for making them so accessible. You can check out Scott's work online at www.skeletaldrawing.com, while Paul's skeletals are best sampled in his 2010 book *The Princeton Field Guide to Dinosaurs* (Paul 2010, second edition, 2016). You can check out Paul's other work at his website (www.gspauldino.com).

This book was not the result of a long-term plan, but instead the result of may years of working as a researcher and fledgling, self-taught palaeoartist. To that end, the co-operation, encouragement and insight offered by my colleagues has been appreciated. I particularly want to thank my fellow scientists, artists and chums John Conway, Michael Habib, Richard Hing, David Martill, Liz Martin-Silverstone, Darren Naish, Luis Rey, Mike Taylor and Matt Wedel.

Naturally, some of the biggest thanks for encouragement go to my family, who have full right to say 'told you so' about trying to make a living by drawing old dead things. Special mention must go to my wife, scale bar and proof reading assistant, Georgia, who's weathered my reclusive, antisocial habits through many palaeoart and palaeontological projects. She does a heroic job of putting up with my affliction of always having half my mind lost somewhere in Deep Time, and her patience for my catchphrase 'Sorry, dear, did you say something?' is becoming the stuff of legend.

Finally, thanks to the online palaeontological community and those who follow it: books like this wouldn't happen without your continued interest, enthusiasm and support. I hope you enjoy it.

About the author and artist

Dr Mark P. Witton is a palaeontologist and palaeoartist affiliated with the University of Portsmouth, UK. As a researcher, he is best known for working on pterosaurs, the extinct flying reptiles that once lived alongside dinosaurs. He specialises in creating scientifically credible restorations of extinct animals for publications and museum exhibitions, and regularly consults on documentaries and films featuring prehistoric animals. His credentials include designing creatures and providing consultancy for numerous films, including the *Walking with Dinosaurs* franchise as well as several BBC and National Geographic documentaries. His patrons include the American Museum of Natural History, New York, and the Natural History Museum, London.

His other books include a comprehensive overview of flying reptile palaeobiology: *Pterosaurs: Natural History, Evolution, Anatomy* (2013, Princeton University Press). If you enjoy the words and art featured here, please consider checking this out.

Website: www.markwitton.com
Twitter: @markwitton

Support for future projects: www.patreon.com/markwitton

Age of Reptiles. Noun.
1. The Mesozoic Era, the interval of geological time from 252 to 66 million years ago, characterised by the presence of reptilian lineages in dominant ecological roles in terrestrial, marine and aerial realms. **2.** A 34m long palaeoartwork in the Peabody Museum, Connecticut, depicting the rise of reptilian lineages through the Palaeozoic and Mesozoic Eras, by Rudolph F. Zallinger, completed in 1947. **3.** Comic series set in the Mesozoic Era created by Ricardo Delgado, published by Dark Horse Comics from 1993 onwards. Known to be highly influential to nine-year-olds obsessed with dinosaurs.

Preface: How many ways can we reconstruct extinct animals?

Children of the 1980s, such as myself, are among the last to remember 'old fashioned' restorations of Mesozoic reptiles as unironic facets of pop culture. Although a lot of revolutionary work on fossil reptiles took place in the 1960s and 1970s, a lag between the scientific frontier and popular culture meant that 1980s palaeo-media remained distinctly 'vintage'. For non-scientists, the revolution was only fully visualised in 1993 when the dinosaur special effects of *Jurassic Park* gave a clear sign that a change in dinosaur palaeontology - now referred to as 'the Dinosaur Renaissance' - had arrived.

The transition from pre- to post-renaissance Mesozoic reptile art was not a smooth one. Media outlets keen to cash in on late 1980s/early 1990s 'dinomania' used any artwork they could for their products. Books and magazines often showed vastly contrasting portrayals of ancient animals. Newer work showed far more active, alert and energetic animal with distinctive and defined anatomy than the relatively sluggish and rotund animals of older works. As a pre-teen of that time, I didn't understand why this was, and I remember trying to marry the two approaches in pictures I drew in the early 1990s. My preference for 'new look' dinosaurs however, helped no end by *Jurassic Park*, had me seeking out media which utilised them instead of sluggish kangaroo lizards. Another 1993 work, Ricardo Delgado's first *Age of Reptiles* comic, was a great source for new-look Mesozoic species, and resulted in a lot of Delgado-inspired drawings on my bedroom walls.

An explanation for this rethink in Mesozoic reptile appearance finally trickled down to me in the early 2000s, courtesy of palaeoartist and researcher Gregory S. Paul. Already a fan of his skeletal reconstructions and paintings, I found his words had even more impact than his illustrations. It turned out that Paul and other individuals in the '70s and '80s had been taking a more critical eye to the process of reconstructing extinct animals, with some surprising results. As a teenager - now old enough to start thinking more critically about palaeontology and palaeoart - Paul's confident assertions about the biology and life appearance of fossil animals were inspirational. Like a palaeontological Sherlock Holmes, Paul could 'read' the life appearance of long-dead animals from fossil clues. It turned out soft-tissues could be reconstructed in detail from features of skeletons, that missing proportions could be accurately determined for incompletely known species, and that we even knew where to put certain scales and skin folds in our dinosaur art. As early as 1987, Paul had been saying "the common assertion that there is always more than one way to restore a given animal is not true." He wasn't alone in this view. Several other palaeontologists and artists of the 1980s and 1990s were making similar statements, often alongside newly produced, 'Paulian' reconstructions of once variably-depicted taxa. Subjectivity - the personal preferences, opinions and intuition of those making the art - seemed largely redundant in face of this objective, measured approach. Palaeoartworks – which palaeontologist Dale Russell was now calling "windows into the past" – had never seemed more scientific and accurate.

I had discovered Paul's writings as an undergraduate, and continued to read his work as I started my PhD studies into pterosaur palaeobiology in the mid-2000s. But learning more about the scientific process, gaining hands-on experience with palaeontological datasets and increasing exposure to scientific literature put cracks on my understanding that a single palaeoartistic reconstruction should rule one species. Much of the science I had once considered watertight had been questioned, debunked or had never really been certain in the first place. In reality, trying to find consensuses on some issues critical to palaeoartistic processes was quite difficult. Some topics had at least been debated down to narrow ranges of possibilities, but others remained lost among vast gulfs in knowledge. As time went on, it became apparent that palaeoartists of equal prestige to Paul were still creating art of extinct animals which differed in fairly major ways. They were certainly tighter on topics like musculature and posture than the art I knew as a child, but differences in bulkiness, proportions, integument types, skull shapes and other substantial differences were still apparent. Some artists were even contradicting their older artworks - those same ones which had seemed so darned *right* at one time. This 'one species, one reconstruction' idea was not faring well under scrutiny.

Since finishing University, palaeoartistry has taken up more of my time and I increasingly find myself wondering how to credibly put long-dead species back together. Our knowledge of fossil animals continues to swell, but greater knowledge does not always bring greater clarity. Indeed, many palaeoart-relevant topics – examples include the integuments of fossil reptiles, the likelihood of 'lips' and 'cheeks' on dinosaur faces – are more complicated than ever. Assumptions that once seemed certain may now be only partly right, or elements of a knowingly complicated, but poorly understood picture. Some ideas have been demonstrated as unlikely without sufficient information to form a replacement hypothesis or, worse, found to be essentially unknowable given limits of the fossil record and methods of comparative anatomy. And this is to say nothing of recent, compelling observations that our traditional palaeoartistic approaches can fail to produce animals consistent with those of modern times (see, for discussion, the 2012 book *All Yesterdays* by John Conway, Memo Koseman and Darren Naish).

The more we find out, the more we investigate, the less likely it seems that a single, objective reconstruction can be applied to any fossil animal. Retrospectively, we can say that what Paul and others demonstrated in the late 20th century was how to best lay foundations for a restoration within the limits of current data: ascertaining reasonable ideas of posture, proportion, size, some aspects of muscle layout, and a viable range of soft-tissues. Beyond this 'base level' of reconstruction, however, knowing which artwork is most accurate is difficult. So long as an artwork doesn't directly contradict fossil or zoological data, or violate known development of anatomies across evolutionary trajectories, we have to consider them credible portrayals of the past. Strive as we might, palaeoartists are not recreating a single, incontrovertible view of the past, but an interpretation of it, constrained by the limits of contemporary knowledge.

If this is true, then palaeoartistry actually must include a degree of subjectivity. Scientific data takes us so far, but then the personal preferences and opinions of those producing the art must take over. Palaeoartists might provide windows to the past, but the glass is tinted by their leanings towards certain styles, colours, sources of artistic inspiration and, perhaps most importantly, their take on the mechanics of the natural world. It is obvious that palaeoartists vary on this matter quite considerably. We see emphases on nature as being lean, savage and cruel; as cute and playful; as muscular and awesome; as quiet and peaceful, or as any other combination of mood and tone. Depending on the artist, a given animal might be a sharply-spined, violent predator or a softly-feathered, careful opportunist. Both reconstructions would be equally valid. I would have baulked at the idea 20 years ago, but the whims of artists will continue to vary the way extinct animals are restored. This will only change with discoveries of the most miraculous fossils where all details of life appearance are preserved, or the realisation of a futuristic theme park where dinosaurs are brought back to life through advanced cloning techniques (see, for discussion, Seymour Skinner's great American novel, *Billy and the Cloneosaurus*).

That brings us to this collection of my palaeoartworks. With all said above in mind, it seems relevant to explain what preferences inform my own depictions of ancient life. My take on prehistory is strongly inspired by the animals I see every day. It's easy to become blasé to the birds, mammals, arthropods and other animals we see around our towns and local countryside, but they also provide us with the most sustained opportunities for witnessing animal behaviour and anatomy in action. The genetics governing their lives and the laws of natural selection are the same that influenced their vastly ancient relatives, and we can almost see evolution in action when watching these animals communicate, forage, negotiate partnerships, rear offspring, fend off predators or experiment with behaviours beyond their adaptive means. The message I take from this is of nature being resourceful and balanced, capable of shaping organisms into marvels of functional anatomy, and certainly biasing success to the strongest, boldest individuals. However, I think we sometimes overstate its cruelty, mercilessness and drama. That aspect is certainly there, but so is a surprising degree of timidity, silliness and inefficiency.

Consequently, I have little interest in depicting ancient species as nothing but instruments of violence and noise; nor for showing extinct animals as so supercharged and indestructible that they operate outside the constraints of their flesh and bone anatomy. I found the latter ideals appealing as a younger individual, but can't rationalise it as an adult scientist or natural history artist. I strive to create what I want to see: Mesozoic dinosaurs, pterosaurs and other extinct species as they were in life, going about activities we would witness during chance encounters, with the all the purpose, caution, resourcefulness, and goofiness, of actual living beings. If that's what you take from this compilation of images, then I'll consider my goal achieved.

Careful now: we're only predatory dinosaurs

One of my most vivid recollections of first reading Gregory S. Paul's 1988 book *Predatory Dinosaurs of the World* is his discussion of predatory dinosaurs as lazy opportunists. If they were anything like modern predators, they probably sought the most easily subdued and overpowered prey while avoiding larger, heavily armed opponents. They probably slept much of the time and used underhand, devious tactics – hiding in shadows, nocturnal stalking, etc. – to gain every advantage over their prey. As a child raised on palaeomedia showing quite the opposite, this was quite a revelation.

This set of images attempts to capture core themes of this idea. The reclining *Torvosaurus tanneri*, below, shows a large theropod at rest, doing little else but tending her nest. This, or a close variant on this image, is surely how we would have encountered most extinct, carnivorous theropods should we have seen them in life. The restoration here is of deliberately 'reptilian' nature. There are lots of spines, folds, bumpy textures and sags of skin. It nods to the likelihood that not all theropods would have looked like overgrown birds, the fact that we know some theropods were extensively scaled, and attempts to embody the work of classic palaeoartists Zdenek Burian and Charles Knight. Their dinosaurs were frequently adorned with all manner of wattles, dewlaps, frills, skin folds, and elaborate scales, and made for striking, believable takes on many extinct species. While obviously speculative, such details are great aids to convincing viewers into thinking they're looking at a picture painted from life and not an image dryly reconstructed from fossil bones.

Both my *Eotyrannus lengi* and *Neovenator salerii* paintings (p. 10, 12-13) attempt to capture hunting dinosaurs exploiting circumstance to stack odds to their advantage. *Eotyrannus* patrols the edge of a wildfire, these being known as common events in its habitat of in lower Cretaceous Britain, in the hope that panicked animals will blunder into striking range. More ambitiously, a *Neovenator* creeps towards two larger dinosaurs – rebbachisaurid sauropods – in near pitch darkness, using superior eyesight (as is often the case

Reclining *Torvosaurus tanneri* and nest
Late Jurassic (Kimmeridgian), USA. (2013, revised 2015)

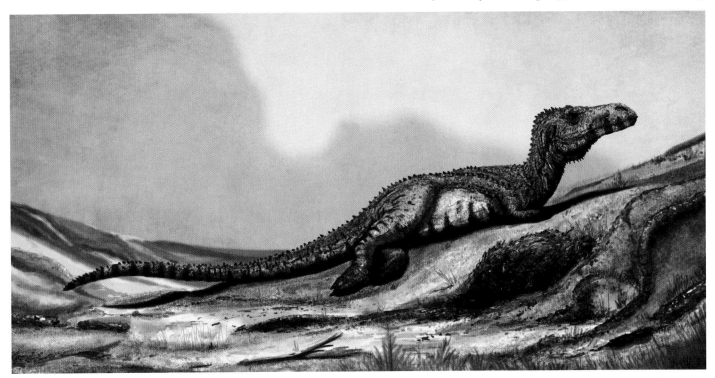

in predators) to pinpoint its quarry while they only roughly sense the danger. This image tries to emphasise the caution needed by all predatory species. Large theropods were certainly powerful animals, but they would still need to work hard at setting ambushes, avoiding self-injury, and - in this case - being extra careful not to give panicked, half-blind, multi-tonne prey animals something to strike at.

Of course, life as a predatory dinosaur probably wasn't all slow stalking and opportunism. Doubtless many were happy to pursue prey so long as they stood a chance of a reward at the end of the chase. Such behaviour is shown opposite, where *Velociraptor mongoliensis* chases a juvenile *Citipati osmolskae*. The parent *Citipati* can be seen in the background, too far off to intervene, and I imagine this *Velociraptor* having waited for an opportunity to ambush the smaller, defenceless juvenile rather than fighting through adults for the privilege. Whether such dim fate would fall the sphenodontian *Opisthias rarus* at the jaws of a curious juvenile *Allosaurus fragilis* (opposite, below) remains uncertain. As is commonly seen in our sole living sphenodontian, the tuatara, the *Opisthias* is being boisterous in defence of its home, and that might be enough to scare that inexperienced theropod away. This privately commissioned image was a fun painting to execute and grounded on a real juvenile *Allosaurus* fossil. Note the leaves stuck to the *Allosaurus* pelt, meant to betray previous bouts of tomfoolery before it decided to annoy its neighbours.

Clumsiness is another theme to images in this set. Restored hindlimb musculature of *Aucasaurus garridoi* (p. 14) suggests it was likely a fast moving predator, but it was also very long-bodied, and it's easy to imagine it slipping if it turned too sharply when running at full tilt. I tried to portray the moment this animal realised it had fallen over in this privately commissioned painting, it's embarrassing little arms flailing about like they could do something to help. The famously formidable *Deinonychus antirrhopus* (p. 15) was probably not adverse to the odd wobble either, especially when traversing slimy terrain. Indeed, slide tracks possibly made by *Deinonychus* inspired creation of this privately commissioned image: perhaps even the most famous

***Eotyrannus lengi* stalks a wildfire, looking for panicked prey**
Early Cretaceous (Barremian), UK. (2014, revised 2015)

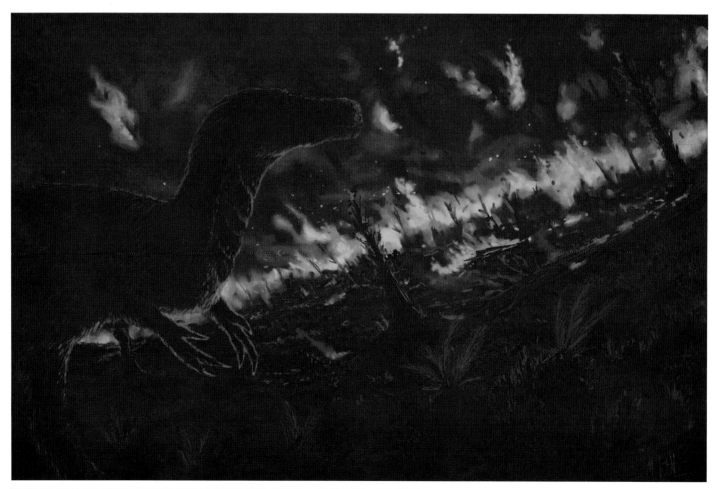

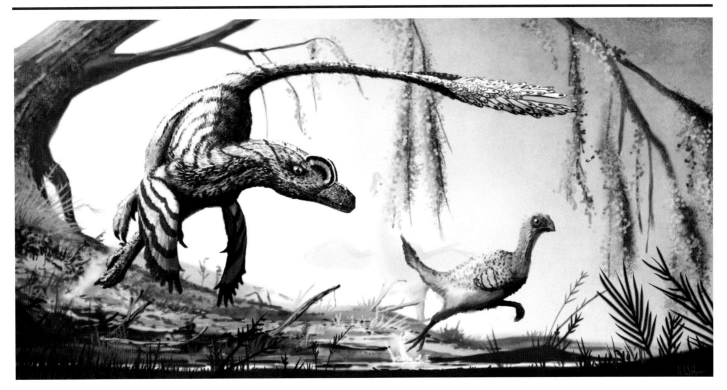

Above: *Velociraptor mongoliensis* chases juvenile *Citipati osmolskae*
Late Cretaceous (Santonian), Mongolia. (2013, revised 2015)

Below: Juvenile *Allosaurus fragilis* and Old Man *Opisthias rarus*
Late Jurassic (Kimmeridgian/Tithonian), USA. (2014, concept by ReBecca Hunt-Foster)

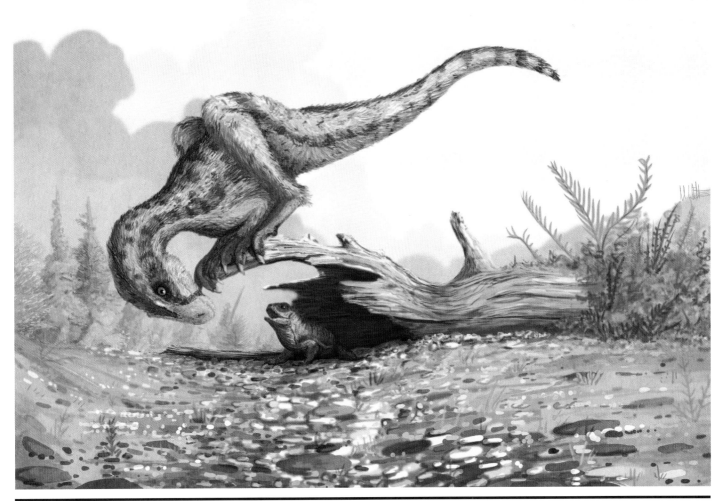

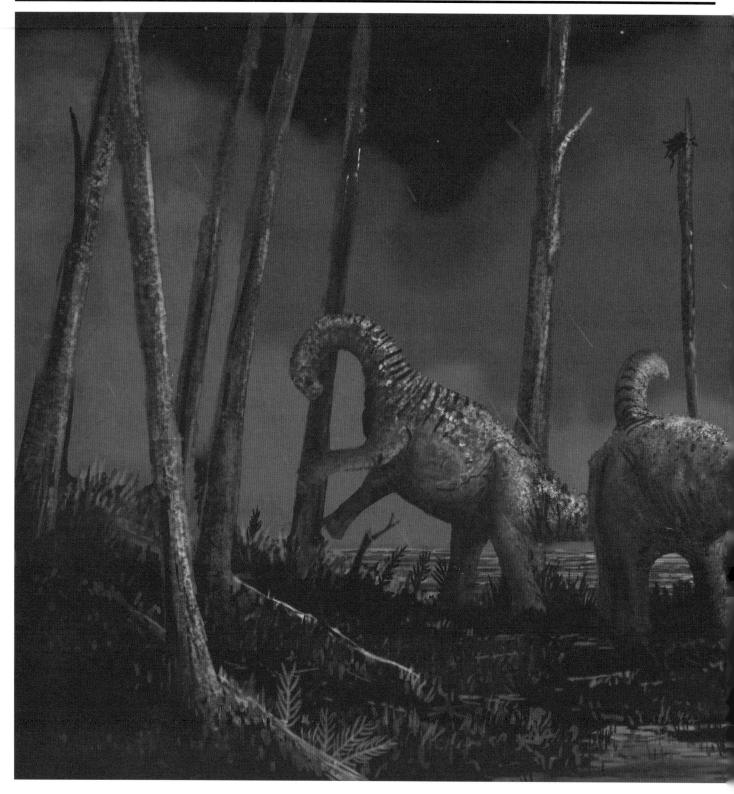

dinosaur predators were not without moments of awkwardness.

Theropod machismo is subverted for a final time on pages 16 and 17, where the softer, kookier side of their nature is played to the fullest. In one image, *Therizinosaurus cheloniformis* has been restored to somewhat resemble a giant wood pigeon (*Columba palumbus*). As pot-bellied herbivores descended from carnivorous ancestors, therizinosaurids are already antitheses to common conceits of theropod dinosaurs, and restoring them in the guise of birds which are often a bit clumsy and daft puts icing on that cake. The implication of this image, that Mesozoic theropods would engage in strange, perhaps comical-looking communicative displays and behaviours, or

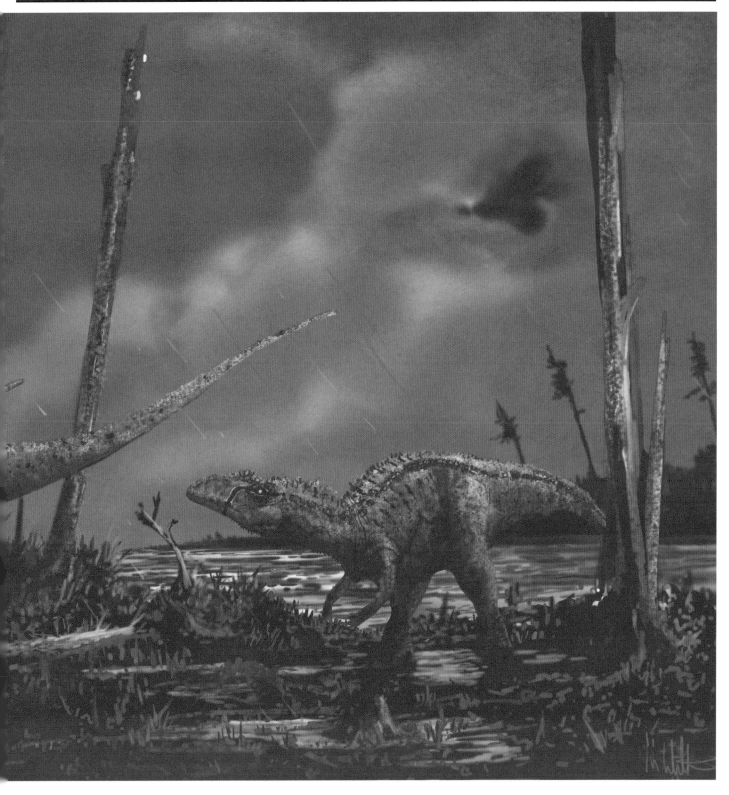

Neovenator salerii stealthily approaches two rebbachisaurids
Early Cretaceous (Barremian), UK. (2014, revised 2015)

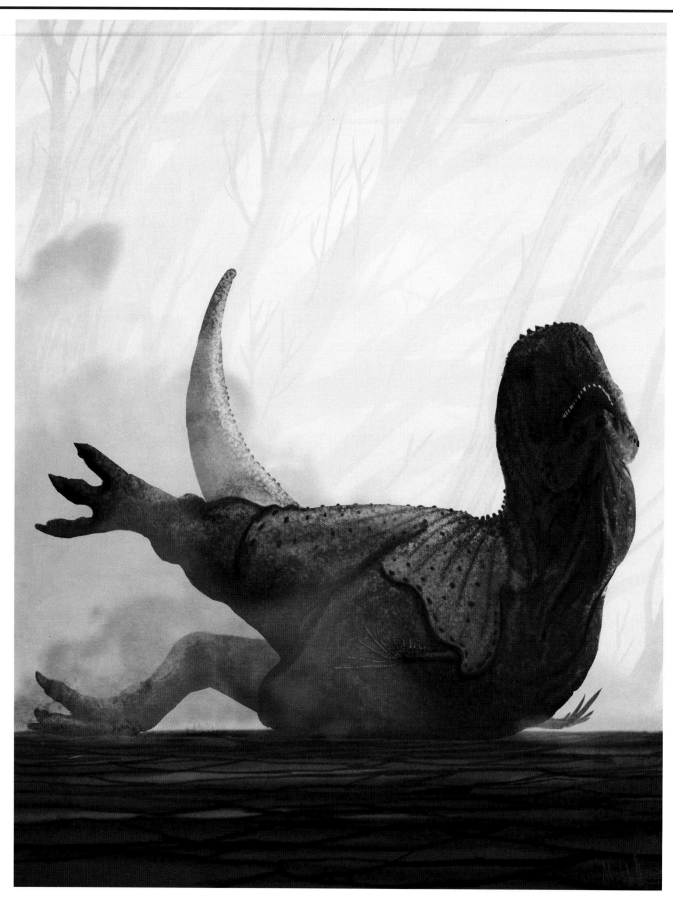

Aucasaurus garridoi: When Theropods Go Wrong
Late Cretaceous (Campanian), Argentina. (2014, concept by Felix Bridel)

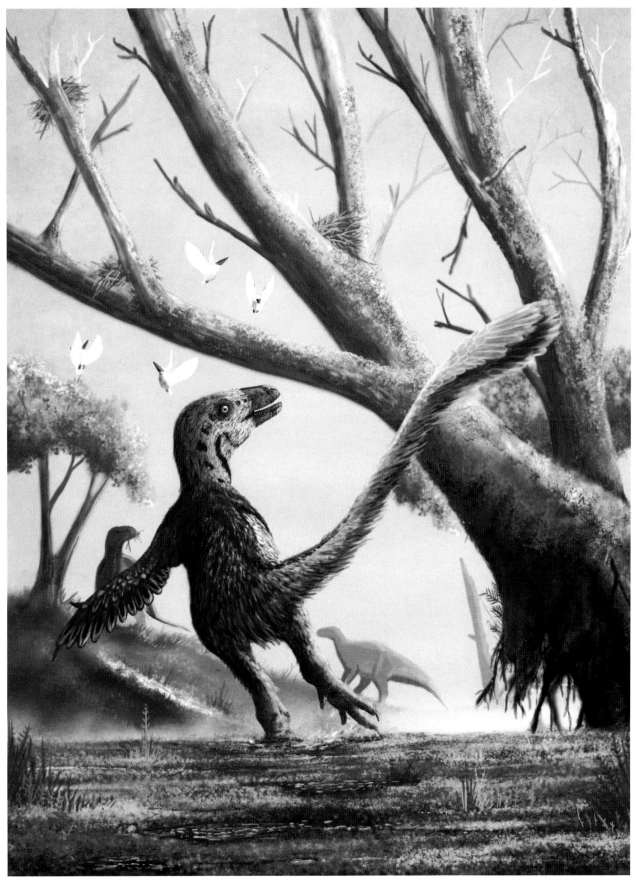

Deinonychus antirrhopus making a pratfall
Early Cretaceous (Aptian/Albian), USA. (2015, concept by
ReBecca Hunt-Foster)

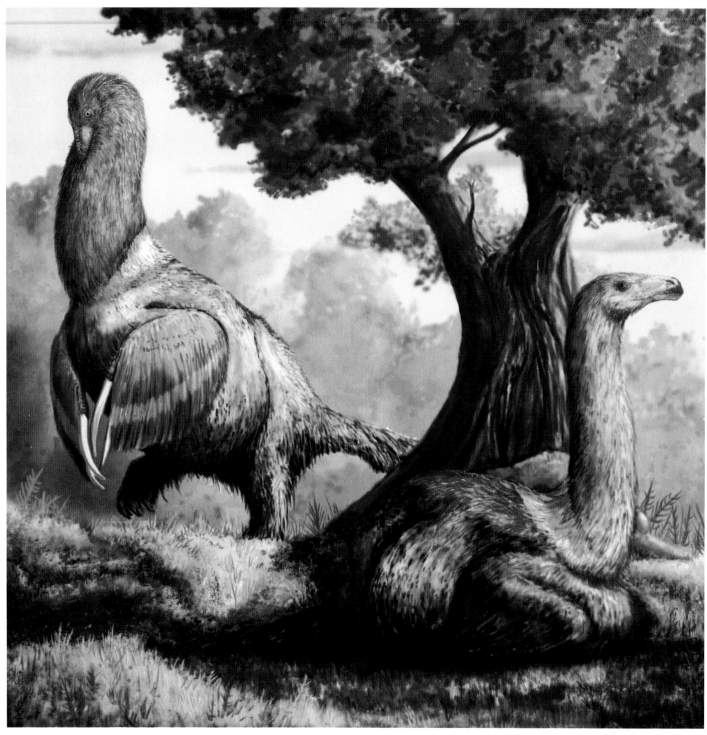

Above: *Therizinosaurus cheloniformis*: Supercoo.
Late Cretaceous (Campanian-Maastrichtian), Mongolia. (2013, revised 2015)

Opposite: *Sinornithoides youngi*: Mr Sits, Mr Stands, and Mr Sunbathes
Early Cretaceous (Aptian-Albian), China. (2013, revised 2015)

make 'cooing' noises rather than roars and snarls, is very appealing to me. I also like the idea of a gang of *Sinornithoides youngi* loafing around like contented birds, ignoring potential prey items like scorpions and small pterosaurs, with one even sunbathing, even if it's not really what my childhood impression of sickle-clawed troodontids was like. Fittingly, *Sinornithoides* is actually known from a fossil skeleton preserved in a crouched, sleeping-like pose: sometimes, even the fossil record gives us reason to think theropods were not all bad, all the time.

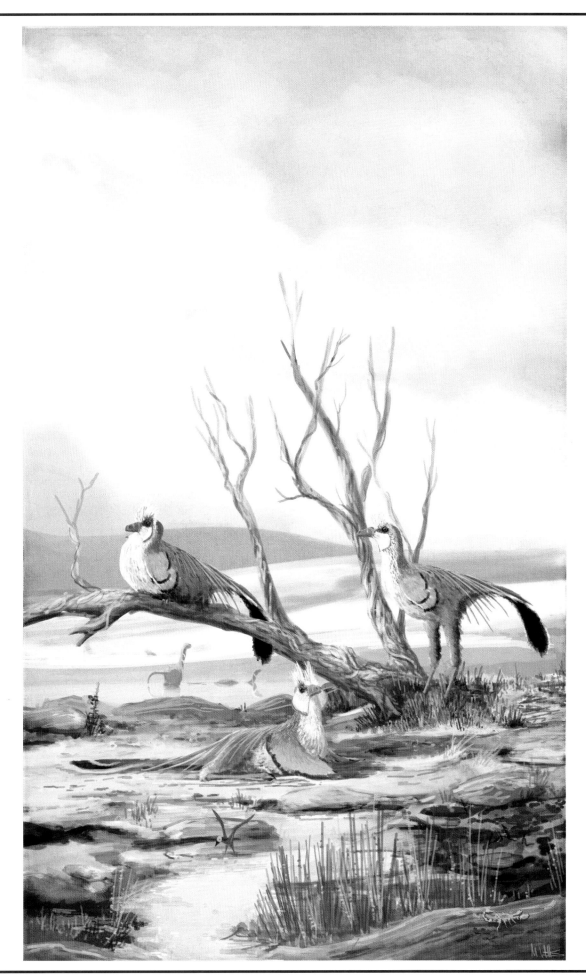

Of Mesozoic seas

It seems that widespread popularisation of seagoing Mesozoic creatures has not occurred yet, at least not at the level seen for dinosaurs and pterosaurs. This is not for a lack of compelling art. Influenced by early fossil discoveries, marine compositions dominate early palaeoart and it was through seaways and oceans that many denizens of the 19th century first experienced life before man. Modern artists (including Bob Nicholls and the late Dan Varner) continue this tradition, excelling at bringing the underwater Mesozoic world to life. My trips to Mesozoic seaways are more limited, in part because I have a better understanding of terrestrial animals and ecosystems, but I would like to address this balance in future.

I often attempt to compose pictures as if viewers are witnessing prehistoric animals in the wild. This was the attitude I took for the *Ophthalmosaurus icenicus* image below. As landlubbers, we'd likely witness submerged marine reptiles when circumstance placed us somewhat above them, perhaps on an elevated shoreline or boat. This view permitted an attempt to show how wide and rotund *Ophthalmosaurus* was. Contrary to expectations, this ichthyosaur was barrel-chested and had a broad posterior skull behind the narrow snout. I took some liberties with its fin shapes. There're plenty of reasons to think derived ichthyosaurs should be restored with dorsal fins and prominent tail lobes, but we don't know much about their diversity in shape or size. Here, I decided to make them quite large and orca-like, giving this large (6 m long) animal an imposing shape. Conveying size in marine scenes is difficult, so small rhamphorhynchine pterosaurs were introduced to provide a frame of reference. It's not a perfect solution – most of us don't instinctively know how large rhamphorhynchines are – but they give some sense

Below: *Ophthalmosaurus icenicus* and seagull-sized rhamphorhynchine pterosaurs, in shallow water
Middle Jurassic (Callovian), UK. (2013, revised 2015)

Opposite: *Pteranodon sternbergi* dives for fish
Late Cretaceous (Santonian), USA. (2011, revised 2015)

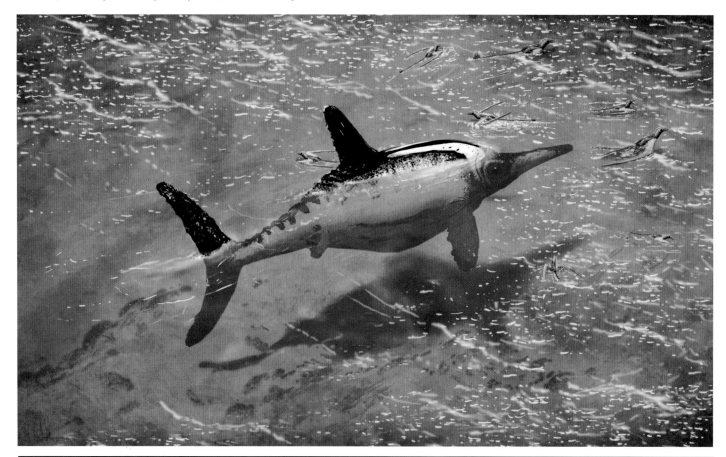

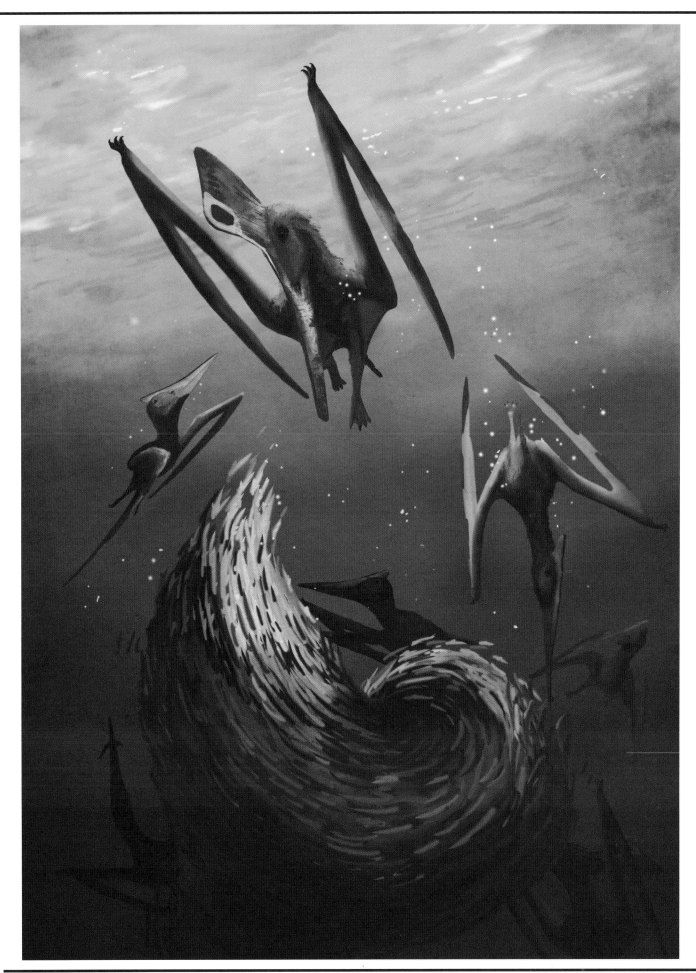

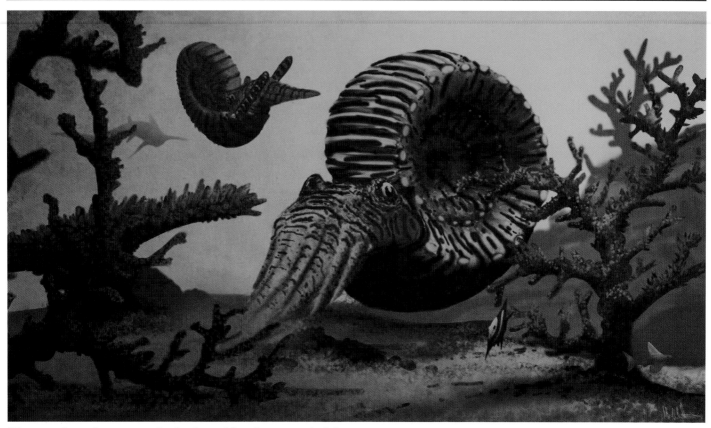

Microconchs and macroconchs (male and female, respectively) of the ammonite *Erymnoceras coronatum*
Middle Jurassic (Callovian), UK. (2013, revised 2015)

of scale, especially once viewers are informed of their roughly seagull-like size.

Animals we rarely see depicted under water are pterosaurs. Until recently, the aquatic skills of flying reptiles were poorly understood, but in just over a decade we've seen research conducted into their swimming traces (scratches in sediment made by paddling pterosaur feet), floating postures and the mechanics of their water escape behaviours (see p. 35, 43). It seems some pterosaurs likely took to water confidently, and certain species - like *Pteranodon sternbergi* - may have routinely entered water to forage for small fish (previous page). My effort to show such behaviour has *Pteranodon* around a piscine bait ball created by other, unseen predators, and the pterosaurs performing shallow dives to pluck fish from the melee. The posture for the diving pterosaurs is a best guess as there are few good modern analogues for swimming pterosaurs (the obvious choice, birds, are of limited use here: experiments show that birds are unusual animals as goes their swimming and floating postures) and, to my knowledge, other artists have not experimented much with this concept. I settled on a pose where the wings were folded sufficiently to lessen drag, but could also be used for propulsion along with kicking feet. Note the relative abundance of smaller females compared to the large, big-crested males in this image, a nod to 1992 work on *Pteranodon* population dynamics by *Pteranodon* guru Christopher Bennett.

Mesozoic seas were not only occupied by vertebrates. Ammonites are famously abundant Mesozoic fossils, and were obviously big players in these marine communities. Unfortunately, these animals represent a whole bucket of frustration for palaeoartists. Many of our marine palaeoartworks should contain ammonites - they are really so abundant as fossils to suggest they were basically ubiquitous in Mesozoic seas – but the fossil record has yet to tell us much about the life appearance of the animal living inside their shells. We know virtually nothing about even basic soft-tissue anatomy of most ammonite species, and thus very little about their appearance and habits. That doesn't leave artists much to work with, and this is something of a problem considering their likely visibility in Mesozoic seas.

We can be confident that ammonites, such as the robust Jurassic species *Erymnoceras coronatum* (above), must have been tentacled beasts living in coiled shells. This is because their closest relatives are

coeloids (octopuses and squids) and, more distantly, nautilus. Unfortunately, nautiloids and coeloids are rather different in many key anatomical aspects, including tentacle counts and eye anatomy, and it's not obvious when the older, ancestral traits of nautiloids were modified into the coeloid condition. Thus, when painting ammonites, we have to make a somewhat subjective call as to which variant we want to depict. Here, I've settled on 10 tentacles and relatively large eyes, making *Erymnoceras* more coeloid-like than nautilus-like. Because *Erymnoceras* also has a wide and flat shell aperture, I took some inspiration from cuttlefish to create a broader ammonite animal than we might be used to. Aspects of eye anatomy were also borrowed from cuttlefish, the eyes being perched high on the body rather than, as in squids, in a lateral position. I found this chimed well with an aspect of ammonite shell morphology – the ornamental 'lappets' of microconch (male) ammonites. These projections of the shell aperture present obvious obstructions to laterally situated eyes, necessitating eye displacement above or below these structures.

An earlier version of this *Erymnoceras* image showed the two ammonites floating about in water, not up to very much – this seems a fairly conventional way of restoring them. But when retooling this image last year I thought it would be more interesting to show ammonites in a different light – foraging on the sea floor. To that end, the macroconch (the big female) is depicted routing through sediment in search of food, her diminutive male in tow. This idea is supported by nektobenthic (animals which swim, but largely hang around the seabed) habits having been proposed for a number of ammonite lineages.

Ammonites are not the only mysterious Mesozoic molluscs. Giant coeloids, seemingly equal in size to our modern giant and colossal squids, evolved several times during the Mesozoic. Their fossil record is extremely poor, only rare preservation of their internal skeleton – a structure known as a gladius – betraying their occurrence. Cephalopod gladii are long, slender, weakly mineralised structures occupying the mantle (the 'body' of coeloids) and are not informative structures for artists. At best they suggest something of muscle bulk, but they suggest nothing about body shape, tentacle number or size, swimming ability of anything else that you'd want to know when restoring an extinct squid-like animal. This, in concert with our poor knowledge of extant giant cephalopods, makes the extinct Mesozoic giants hard to reconstruct with anything approaching certainty.

However, if the words 'giant Cretaceous vampire squid' don't stir your imagination, you probably need to check your pulse. These words aptly describe interpretations of *Tusoteuthis longa*, a giant Cretaceous cephalopod with greatest evolutionary affinity to the extant, poorly known vampire squid (note that 'vampire squid' is a misleading name: these animals are more closely related to octopuses than squid). Although we know virtually nothing of *Tusoteuthis* (it is solely represented by huge - almost 2 m long – gladii), it's hard to resist the temptation of speculating what it may have looked like in life. Taking inspiration from our own giant cephalopods, which we almost entirely experience through washed-up carcasses, *Tusoteuthis* is shown overleaf as a washed-up, decaying body on a Cretaceous, North American beach. There was some practicality in this decision: coeloid carcasses have no support out of water and slough into tentacle-tangled masses. This is a useful way to hide those anatomical uncertainties! However, it can still be seen that, like modern vampire squid, this *Tusoteuthis* has large flippers either side of the mantle and tentacles of equal length, with significant webbing between them. As a significant source of free seafood, the *Tusoteuthis* is being investigated by two beachcombing dinosaurs, *Troodon formosus*, while other feathered dinosaurs flutter in from the forest around them. I like to think this juxtaposition hits two notes: firstly mixing marine and terrestrial faunas, and secondly depicting a combination of well-known and almost entirely mysterious fossil species.

Overleaf: Two *Troodon formosus* scavenge the washed up remains of a 'giant vampire squid', *Tusoteuthis longa* Late Cretaceous (Campanian), USA. (2016)

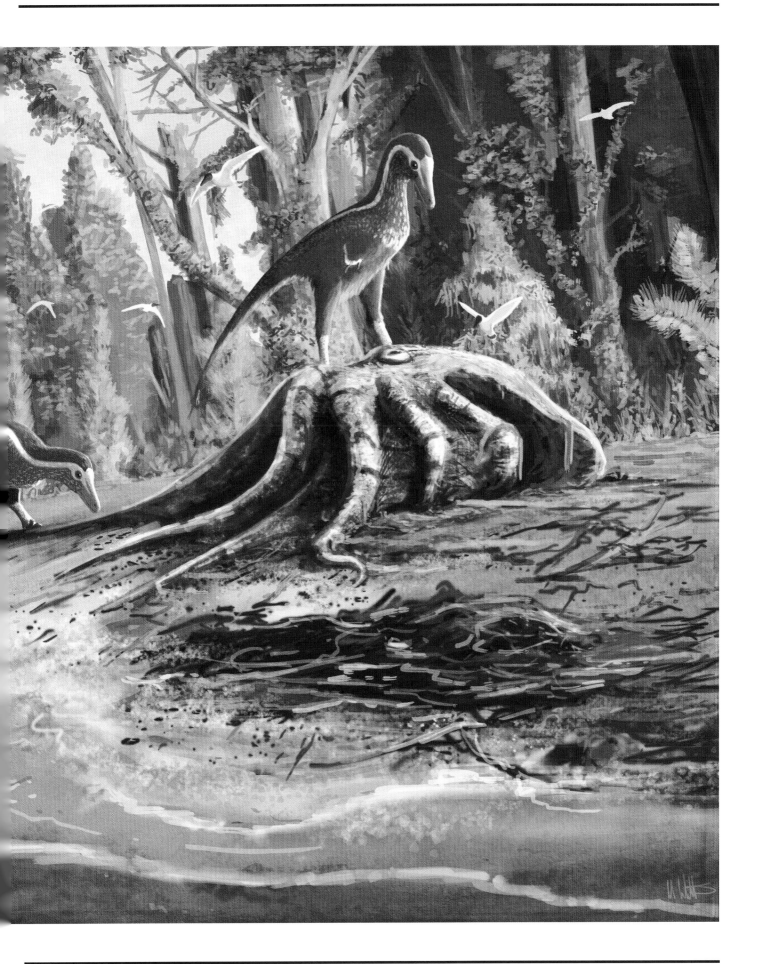

Sauropods: the (second) best animals

Scientists have proven that the second finest group of animals to ever evolve were the sauropods, those long-necked, frequently gigantic herbivorous dinosaurs which are iconic of not only Mesozoic life, but palaeontological science. Few animals represent the awe and mystery of bygone ages more than sauropods, and they are without doubt some of my favourite dinosaurs. It helps that they are incredibly fun to restore – even routine scenes are made unusual and memorable by their outlandish proportions and scale.

Of course, those proportions and issues of size also make them complex subjects for artwork. Their long necks and tails were not, as sometimes shown, able to twist around like a pair of snakes, and it can be difficult to fit them in a frame without their features shrinking to a disappointingly small size. Sauropod faces are fascinating, for example. They were probably covered in a lot of interesting soft-tissues (at least indicated by their peculiar, enormous nasal anatomy) and possess an unusual arrangement of features. But they can be difficult to render as anything other than small, distant shapes without breaking sensible rules of composition. And conveying just how big sauropods are - not just large, but the largest terrestrial animals of all time - is a challenge in itself, requiring a good understanding of how we appreciate light, perspective and detail at long distance. You can sometimes spot obvious 'scale items' in sauropod art, where trees or other animals are added in places that negatively impact the composition but are deemed necessary to sell the size of the subject animals. It's probably not a coincidence that palaeoartists who excel at rendering landscapes are often very good at depicting sauropods, as their reconstruction is basically akin to illustrating a living hillside or mountain. Sauropod art can fall a bit flat in inexperienced hands

One loutish *Mamenchisaurus youngi*, and a disinterested one Late Jurassic (Oxfordian), China. (2015)

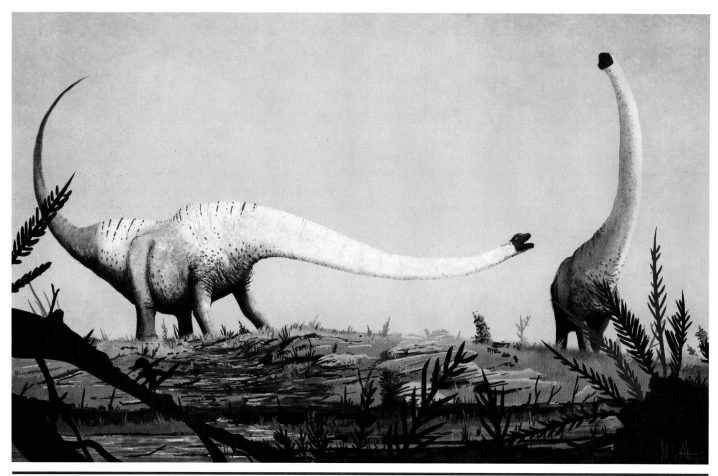

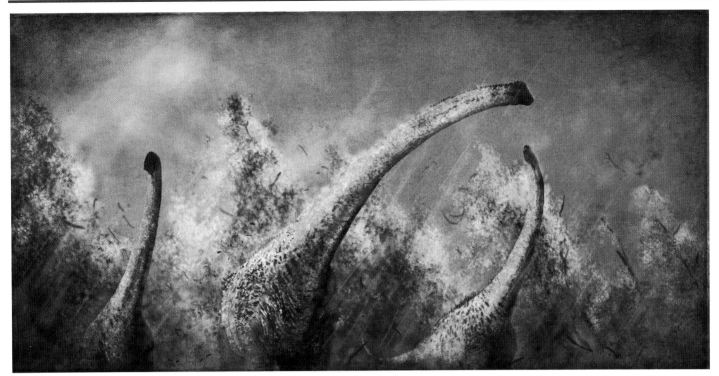

Pelorosaurus conybeari braves a storm
Early Cretaceous (Berriasian-Valanginian), UK. (2013, revised 2015)

but, when handled well, depictions of these animals are among the best palaeoart has to offer.

Despite their outwardly strange appearance, sauropods must have behaved in similar ways to all other animals. When communicating to other individuals they may have adopted specific postures and movements to emphasise their intent and status. An attempt to show this sort of behaviour is seen opposite, where a *Mamenchisaurus youngi* threatens a conspecific via a stooping neck, elevated tail and (indicated by the open mouth) some sort of vocalisation. I imagine it's hissing or making a deep, throaty belch, like you'll hear around conversational emus or crocodylians. The pose and colouration was inspired by a much smaller dinosaur, the noisy, boisterous and extant black headed gull (*Chroicocephalus ridibundus*), a commonly seen – and heard - bird species around my home. This stance is at odds with the common, heroic 'rear up and roar' pose often seen in dinosaur palaeoart, but modern dinosaurs threaten each other far more with stooping, low stances than operatic, rearing ones. It is, of course, speculative to show sauropods using similar communication strategies to birds, but, as with all components of palaeoart, we are probably best served by grounding unknown aspects of the past in data from the present.

I am strangely fascinated by the relationships between sauropods and weather. I probably owe this in part to being British, which makes me genetically predisposed to view any meteorological activity as a source of interest and topic for conversation. But more importantly, I note that most animals are able to escape adverse weather relatively easily through the virtue of being small enough to find shelter. Sauropods, on the other hand, were neither small enough, nor fast enough, to avoid the brunt of sudden, adverse weather or extremes of temperature. Like ships at sea, they must've simply rode out whatever Mesozoic climates threw their way, their enormous bulks and thick hide safeguarding them against baking temperatures, soaking rain and abrasive wind. This romantic concept inspired the *Pelorosaurus conybeari* image above, the three large brachiosaurs braving an Early Cretaceous storm. We know such storms took place during this time, the palaeoenvironment *Pelorosaurus* called home having a highly seasonal climate that included long, dry summers occasionally punctuated by intense precipitation.

Another image focusing on sauropods adapting to extreme environments is seen overleaf, where the famous North American Jurassic sauropod *Camarasaurus supremus* is depicted as a desert specialist. Southwestern regions of North America were arid and desert-like during the Late Jurassic, and we have to wonder how dinosaurs of those areas

coped with those conditions. They may have used similar strategies to modern species, such as storing fats and water in specific regions of their body as reserves for lean times (in modern reptiles and birds, these are mostly stored around the abdomen and at the base of the tail); having light skin tones to reflect solar radiation; possessing large, sealable noses to limit water escape; and shading their eyes with long, eyelash-like filaments or scales. All of these adaptations can be seen on this *Camarasaurus*, along with a few spine-like scales and fatty tissues behind the head serving as display structures. Such decorations are common in modern reptiles, and might well have occurred in ancient dinosaurs too. The resultant image is not a typical depiction of *Camarasaurus,* but nor is it one which can be falsified by the fossil record. Most adaptations to living in extreme climates leave little evidence on skeletons, including those large stores of fatty tissues (so no, those 'sailbacked' dinosaurs like *Spinosaurus* and *Ouranosaurus* were probably not fatty humpbacks). But it stands to reason that sauropods and other dinosaurs frequenting desert environments might have been differently adapted, and thus of rather distinct appearance, to those inhabiting more equable climes.

One of my favourite sauropod art projects was executed in 2009 when working with friends and colleagues Mike Taylor, Matt Wedel and Darren Naish on artwork to promote then-new research on sauropod palaeobiology. The study concerned the habitual attitude of sauropod necks. Historically restored as upright, the late 1990s saw some arguing for sauropod necks being perpetually horizontal. I remember seeing this for the first time in the 1999 BBC documentary *Walking with Dinosaurs* and thought it looked odd, but the convincing CGI of the programme helped sell it to many: we still see sauropods restored in this way today.

Camarasaurus supremus **as a desert specialist**
Late Jurassic (Kimmeridgian/Tithonian), USA. (2014, revised 2015)

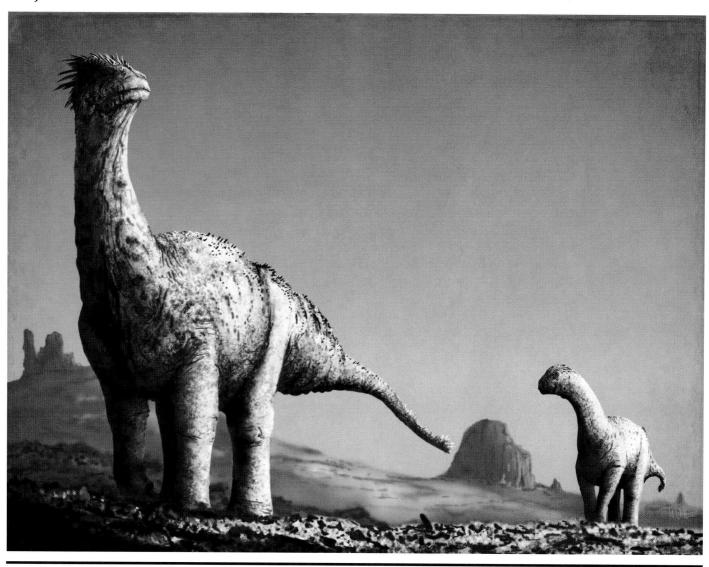

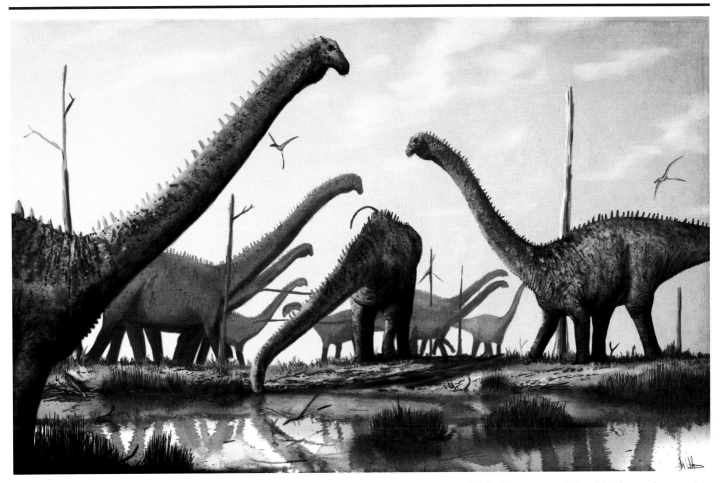

Diplodocus carnegii herd in the early morning Late Jurassic (Kimmeridgian/Tithonian), USA. (2009, revised 2015)

In their paper, Mike *et al.* challenged the notion of habitually-horizontal sauropod necks by examining x-rays of living, awake terrestrial animals to see how their necks were typically held. They found that all of them – even those with only a single neck vertebra – had elevated necks most of the time (and yes, this includes species which look to have horizontal necks, like rodents. The external appearance of animal necks are not reliable indicators of vertebral posture). Thus, unless sauropods were completely different to all other terrestrial vertebrates – which seems unlikely – they probably held their necks upright unless engaging in a specific behaviour, like drinking or foraging.

To help promote this research I was asked to produce artwork of one of the most famous dinosaurs of all, *Diplodocus carnegii*, showing the neck posture predicted for sauropods by living animals (above). Working on this image was great because Mike, Matt and Darren not only have good eye for depicting palaeontological hypotheses, but are also huge palaeoart nerds. We discussed many aspects of the picture in some detail, for instance deciding that most of the animals should have elevated necks, but that one individual with a different pose would demonstrate their findings applied to *typical* neck posture, not *constant* neck posture. We spoke about how extensive the spines along the backs and necks of the animals should be, about details of colouration, and unanimously agreed to homage the *Brontosaurus* in Rudolph Zallinger's famous *Age of Reptiles* Peabody museum mural (the pterosaur beneath the neck of the left animal is a nod to his work, which has a similarly placed red pterosaur alongside a sauropod neck). It stands out as one of my most informed and interesting experiences of producing art for clients.

Matt, Mike and Darren (along with fellow palaeoartist Brian Engh) are also behind the science informing the final image in this set: neck-sparring *Brontosaurus excelsus* (overleaf). *Brontosaurus* might be thought of as the quintessential 'generic' sauropod, but it is actually unusual in many respects, especially it neck anatomy. The aberrant, enormous and strangely proportioned neck vertebrae of *Brontosaurus* and other apatosaurine sauropods have long defied explanation,

but recent work suggests they might be adapted for combat. *Brontosaurus* neck bones show signs of having elevated leverage for neck musculature, expanded areas for muscle attachment and perhaps even anchors for bosses or horns on the underside of each vertebra. One plausible explanation of this anatomy is that these animals 'weaponised' their necks, using these long, powerful organs as armoured structures to beat the crap out of each other and other animals.

At this point I want to reiterate that sauropods are really cool.

The apatosaurine neck combat hypothesis (or more simply, 'Brontosmash!') is pure palaeoart gold, and is likely to spawn lots of illustrations as it becomes more widely known. For my own take, I decided a wet, rainy scene would capture some of the drama and scale of two multi-tonne sauropods slugging it out, water splashing from their hides with each impact and tails whipping spray from puddles. This is another picture which owes a debt to Charles Knight, who's ability to produce murky, atmospheric palaeoart was truly first rate. The upright poses of the duelling animals were inspired by palaeontologist Robert Bakker's iconic 1986 'boxing *Brontosaurus*' image, an illustration I remember vividly from teenage years. Bakker's drawing showed apatosaurines duelling with claws and teeth rather than necks, but captured everything that makes sauropods awesome: even something as routine as two animals disagreeing is mind-blowing when those animals exceeded 10 tonnes apiece.

***Brontosaurus excelsus*: Brontosmash!**
Late Jurassic (Kimmeridgian/Tithonian), USA. (2015)

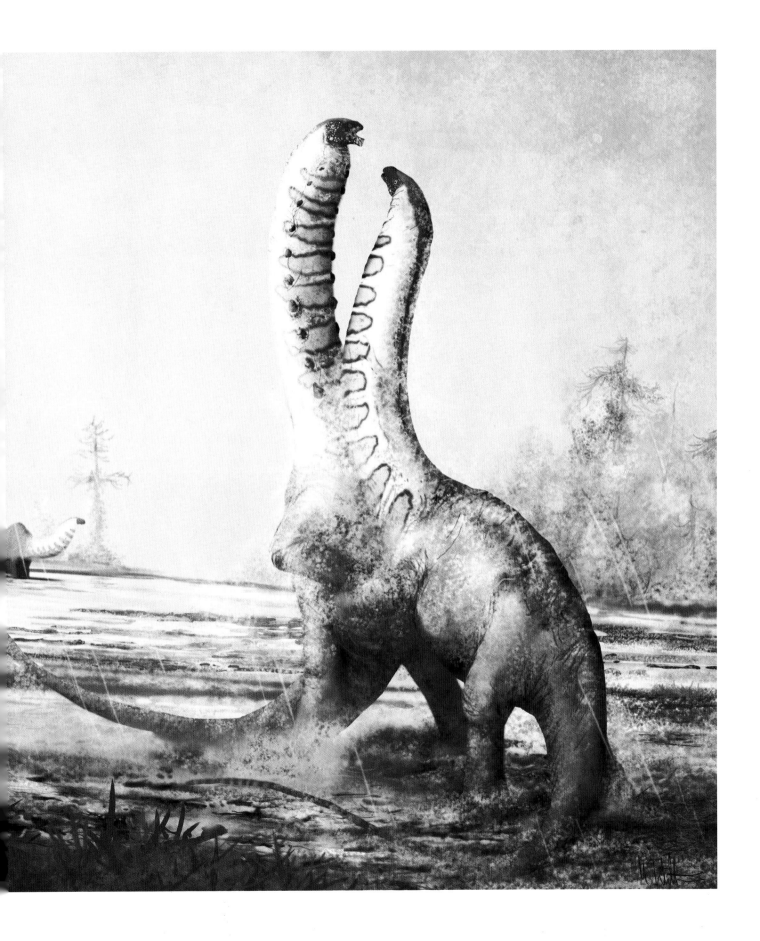

The Mesozoic was full of holes

Many animals appreciate the benefits of shelter and will go to great lengths to create or commandeer burrows and dens. Failing that, others will sequester themselves in loose substrate if they're small enough. Frequent digging or burrowing ('fossorial') behaviour leaves clear functional signatures on animal skeletons and is particularly detectable around limbs and limb girdles. These are often expanded and robust, with shortened limb segments: the optimal arrangement for enlarging muscle mass and maximising power output for moving earth and detritus. We often associate large claws with burrowers too, these structures having obvious utility for dislodging and moving chunks of earth. Smaller, lithe species often rely on their heads to shove aside debris when moving through loose substrate, using strong, broad skulls to do so. A surprising number of Mesozoic forms possessed such adaptations and we can assume that landscapes in the Age of Reptiles were riddled with many dens, burrows and tunnels made by these species.

I was commissioned to illustrate a curious burrowing creature in 2013: the tiny (35 mm snout-vent length) albanerpetontid *Wesserpeton evansae* (below). Albanerpetonids were a long-lived lineage of amphibians seemingly adapted for living in leaf-litter and loose soil. First appearing in the Late Jurassic, they frustratingly only became extinct about 2.5 million years ago - a blink of the eye on the geological time scale. Exceptionally preserved albanerpetontid fossils show their bodies were covered scales, atypical features for amphibians but likely useful for preventing desiccation in dry environments. Their stout skulls were

Wesserpeton evansae, **threat postures in the undergrowth Early Cretaceous (Barremian), UK. (2013, revised 2015)**

Hulkepholis willetti, homeowner
Early Cretaceous (Barremian), UK. (2014, revised 2016)

probably well suited to pushing through loose substrate. But *Wesserpeton*, a species discovered by my colleague and microvertebrate expert Steve Sweetman, may not have only used its head to push around soil and debris. A multitude of broken *Wesserpeton* jaws suggest it was an aggressive, feisty species, routinely fighting with other animals through bites and head-to-head wrestling. Steve wanted to bring this out in the publicity image announcing the naming of his albanerpetontid, so we set two *Wesserpeton* up as posturing rivals. We borrowed threatening body language from modern salamanders for our illustration, this enabling us to show their aggressiveness without the contorted, cartwheeling fighting typical of small herpetofauna. My gut feeling with PR images is to keep things simple, and I was concerned that an image of wrestling, wheeling *Wesserpeton* would look confusing and comical to audiences unaccustomed to small animal combat.

Somewhat more familiar creatures also likely burrowed through the Mesozoic. One such set of animals might be the Crocodyliformes, the reptile group that includes modern crocodylians and their ancestors. Over a dozen modern crocodylian species excavate burrows to live in during periods of cold or aridity, some of their dens becoming complex and branching as individuals modify them over successive years. We don't know for certain that extinct crocodyliforms did the same thing, but many would have faced similar challenges of aridity and coolness, and it does not seem unreasonable to imagine this behaviour as existing in the Mesozoic. This thought was the impetus to reconstruct the goniopholidid *Hulkepholis willetti* as the owner of a fine burrow, as shown above. In keeping with my general preference for showing animals as we can see them naturally, I decided to focus on the burrow entrance rather than interior. In this image of this large crocodyliform striding into a woodland, note its

long forelimbs: these are a characteristic feature of the goniopholidid lineage.

A family of less intimidating animals, the burrowing ornithischian dinosaur *Oryctodromeus cubicularis*, is featured above. The discovery of this species was remarkable for its fossils being found within the remains of a long, twisting burrow, and for several individuals being preserved together, perhaps having perished at the same time. The broad snout and limb anatomy of *Oryctodromeus* are interpreted as two sets of tunnelling equipment, although their development is not so extreme as to imply it was a dedicated, specialist burrower. My reconstruction features (speculative) rugose scales on the heads of the adults to assist shovelling dirt with their faces during their fossorial pursuits. Given that differently aged animals were found in the *Oryctodromeus* burrow, I've shown these animals as having a complex parental behaviour. In this scene, one parent has stayed home with the offspring, while the other is returning and delivering the password for entry. The children are playing up, because, you know,

Oryctodromeus cubicularis family at their front door
Late Cretaceous (Cenomanian), USA. (2013, revised 2016)

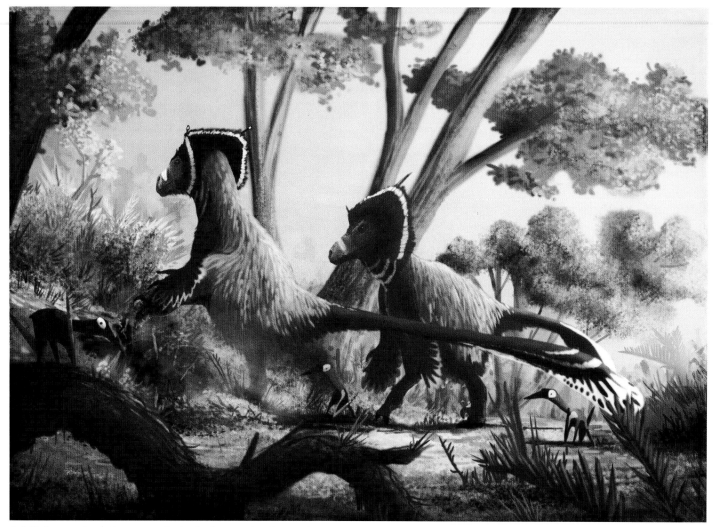

Achillobator giganticus, speculatively depicted as bane of burrowing animals everywhere
Late Cretaceous (Cenomanian-Santonian), Mongolia. (2015)

they're children.

With all these fossorial animals around, it seems likely that some Mesozoic predators would learn to exploit potential prey items seeking refuge in burrows and holes. This notion prompted the speculative reconstruction above, where the large, robust dromaeosaur *Achillobator giganticus* is shown as a specialist burrow excavator. *Achillobator* is not a well known animal, but its robust hips and hindlimbs, short but powerful arms and deep snout indicate it was probably not the fleet-footed predator we typically think of as a raptorial dinosaur. Perhaps it was a slower but more powerful animal, better suited to grappling with prey than chasing it down. It is entirely fanciful to depict this animal with any sort of specialist lifestyle, but given how modern predators can take leanings to particular prey-seeking behaviour, it doesn't seem crazy to think some extinct animals also specialised in various ways. In this illustration an *Achillobator* is using its powerful legs to dig into a burrow while its partner stands by, ready to foil escape attempts by the target animals. Should the prey get to biting distance from the burrow entrance, the feather fans atop the *Achillobator* heads would act to plug the burrow opening while their jaws got to work. This speculation has precedent in the modern day, some foxes having broad, almost square-shaped heads to perform the same function when excavating burrowed prey. Like macabre robins around a gardener, small azhdarchid pterosaurs wait for opportunities to grab scraps and small animals exposed by the busy dinosaurs.

A world of pterosaurs

It's a good job I find pterosaurs an especially interesting set of prehistoric animals. After a PhD, a decade of research and art projects, a book, several consultancy roles and exhibition developments dedicated to these flying reptiles, I think I'm going to be stuck with them for a while. That's OK with me: our understanding of these flying reptiles is enjoying a period of quiet revolution where long mysterious and contentious issues are being addressed through careful study, new discoveries and the application of fresh, critical eyes to historic material. There's never been a better time to be a pterosaur researcher.

Because they have been a major part of my professional life, I've illustrated pterosaurs many times over the years. Learning to render them even half-convincingly has taken a long time because they are very counter-intuitive beasts. Strange proportions, complex joint anatomy, a lack of study into some crucial aspects of their morphology and variable guidance from earlier artists means that there's a lot to consider when it comes to their restoration. It's very easy to

Ornithocheirus simus **launches from water
Early Cretaceous (Albian), UK. (2015)**

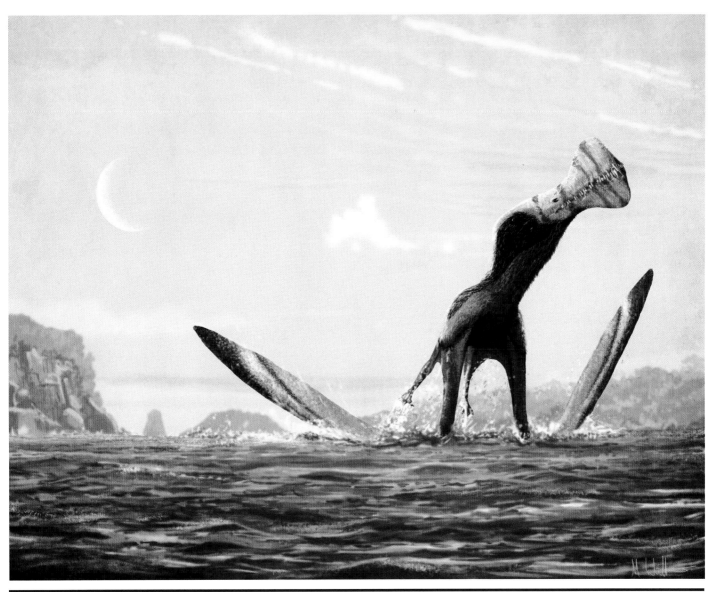

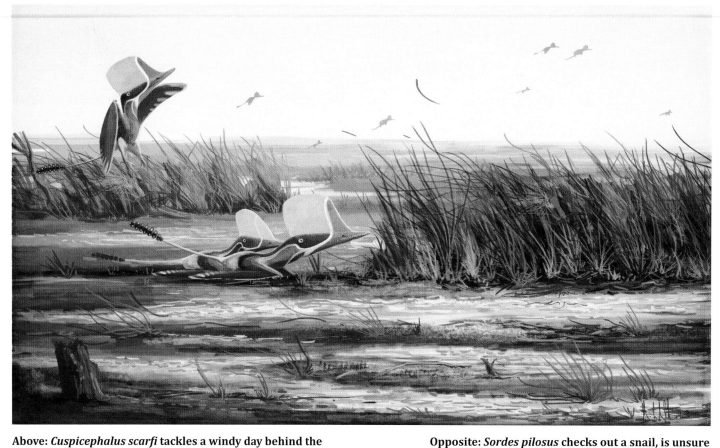

Above: *Cuspicephalus scarfi* tackles a windy day behind the quillworts, one hopes for better weather
Late Jurassic (Kimmeridgian), UK. (2016)

Opposite: *Sordes pilosus* checks out a snail, is unsure
Late Jurassic (Oxfordian/Kimmeridgian), Kazakhstan. (2011, revised 2015)

make pterosaurs look ungainly, ugly, or downright untenable as living organisms. Even artists who excel at restoring other fossil animals come unstuck on them, and particularly on their strange, often outrageous and entirely counter-intuitive body proportions.

The aforementioned revolution in pterosaur understanding has included some surprising insights into how these animals took flight. My colleague and biomechanicist Mike Habib has published numerous articles about 'quadrupedal launch', a strategy where pterosaurs took off using effort from their forelimbs as well as their legs. As odd as this sounds, several modern bat species take off in this way and calculations show this method of takeoff is actually more efficient than the legs-alone launch used by birds. On land, quadrupedal launch could be easily achieved using a standing start, but pterosaurs may have struggled to take off so easily from water. Quadrupedal launch theoretically works from a floating position, but required the pterosaur to 'row' itself mostly free of the water to escape suction and achieve a height sufficient to push off from the water surface. We should imagine these animals 'skipping' across the water surface as the first phase of their water launch - an attempt to show what this might look like is seen on page 35, featuring the large ornithocheirid *Ornithocheirus simus*.

Pterosaurs were probably powerful fliers, but that does not mean they were immune to the effects of bad weather. I often wonder what pterosaurs with large headcrests did when weather conditions became particularly awful. Bird watching at my local mudflats reveals one solution to this: hiding behind something and hoping everything will be OK. Gulls in open settings and strong winds can be seen using this tactic, and if these crestless, streamlined flying animals struggle in gales, perhaps those pterosaurs with billboards stuck rudely to their faces would have had even more trouble. In the above image, the Jurassic wukongopterid pterosaur *Cuspicephalus scarfi* is hunkering down behind a large set of quillworts, facing into the wind to maximise their streamlining. Sexual dimorphism is depicted with crest size and colouration, there being evidence that at least some wukongopterids had gender-specific crest development.

Pterosaurs hunker down for different reasons in the images opposite and overleaf. In the former, the small Jurassic species *Sordes pilosus* decides if a snail

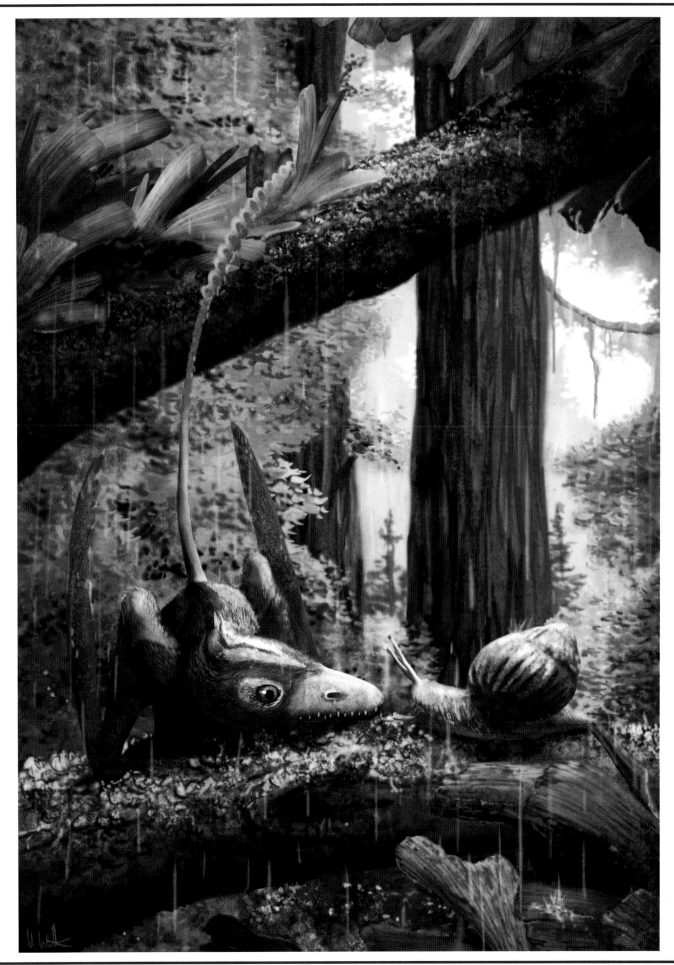

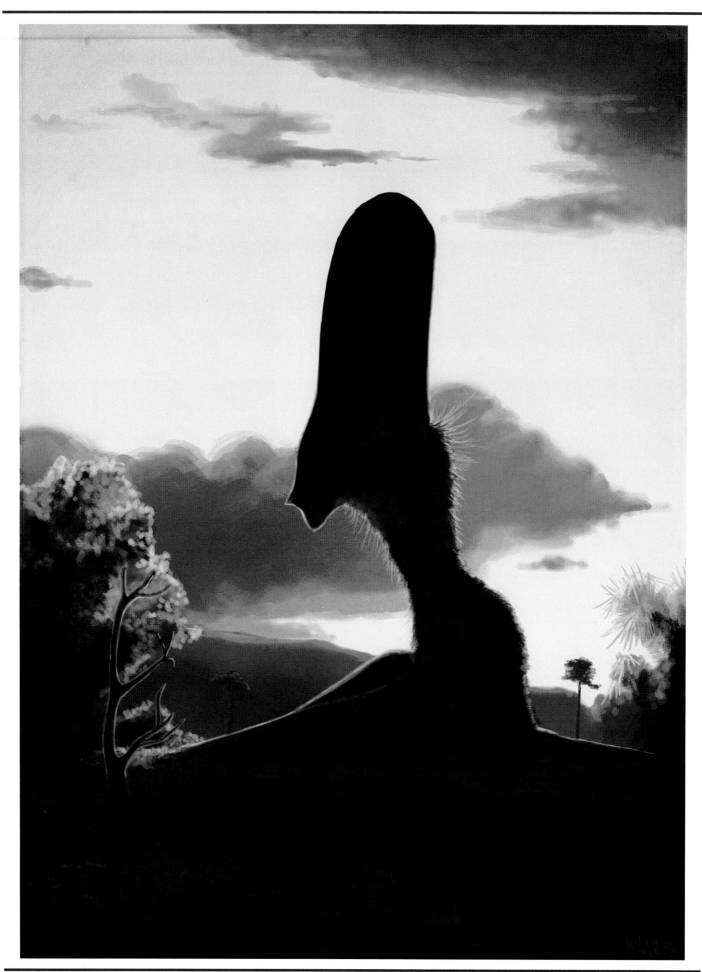

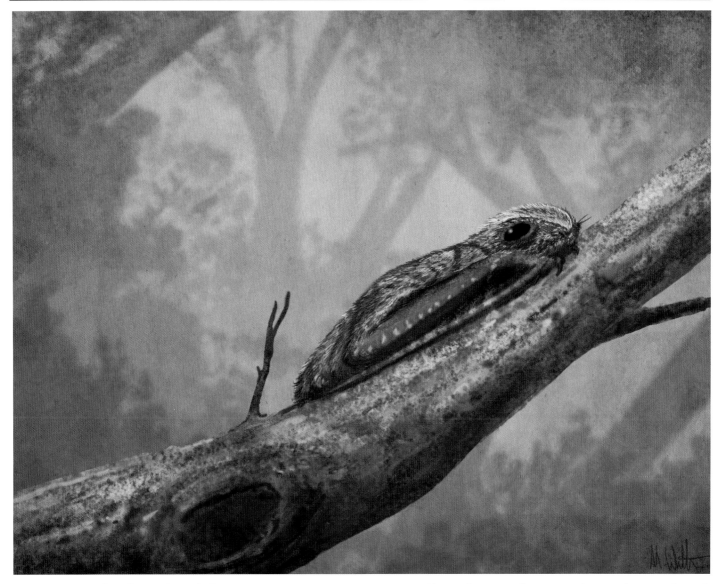

Above: *Anurognathus ammoni* pretends we can't see it
Late Jurassic (Tithonian), Germany. (2011, revised 2015)

Opposite: *Tupandactylus navigans* is fuzzy
Early Cretaceous (Aptian), Brazil. (2011, revised 2015)

would make a good meal. *Sordes* holds a special place in pterosaur history as the first flying reptile discovered with unambiguous evidence of 'pycnofibres' - the filamentous pelage now known from multiple pterosaurs and probably common to the entire group. *Sordes* is rarely depicted in artwork, and is even more rarely given something to do other than sitting around with a shaggy coat of fuzz. This image was a deliberate attempt to break this trend and show it behaving like a real animal, exhibiting curiosity at the presentation of an unfamiliar object and being coloured like a woodland bird. That's not to say we have no room for the 'pterosaur sitting around with a shaggy coat of fuzz' meme however, but I've transferred it to another animal, the Cretaceous *Tupandactylus navigans* (opposite). The raison d'etre for this image, drawn for a book chapter on pterosaur soft-tissue anatomy, was to draw attention to pterosaur filaments. Back-lighting the animal to reveal a filamentous halo around a silhouetted form seemed like an inventive way to do this, and made a potentially dry image more than strictly illustrative.

Two extremes of lifestyle for the Jurassic pterosaur *Anurognathus ammoni* are shown in the next two paintings. Overleaf, we see this small pterosaur as the

Overleaf, left: *Anurognathus ammoni* pursues insect prey as night draws in
Late Jurassic (Tithonian), Germany. (2011, revised 2015)

Overleaf, right: *Caviramus schesaplanensis*, looking like it's off to audition for *Game of Thrones*
Late Triassic (Carnian/Norian), Switzerland. (2011, revised 2016)

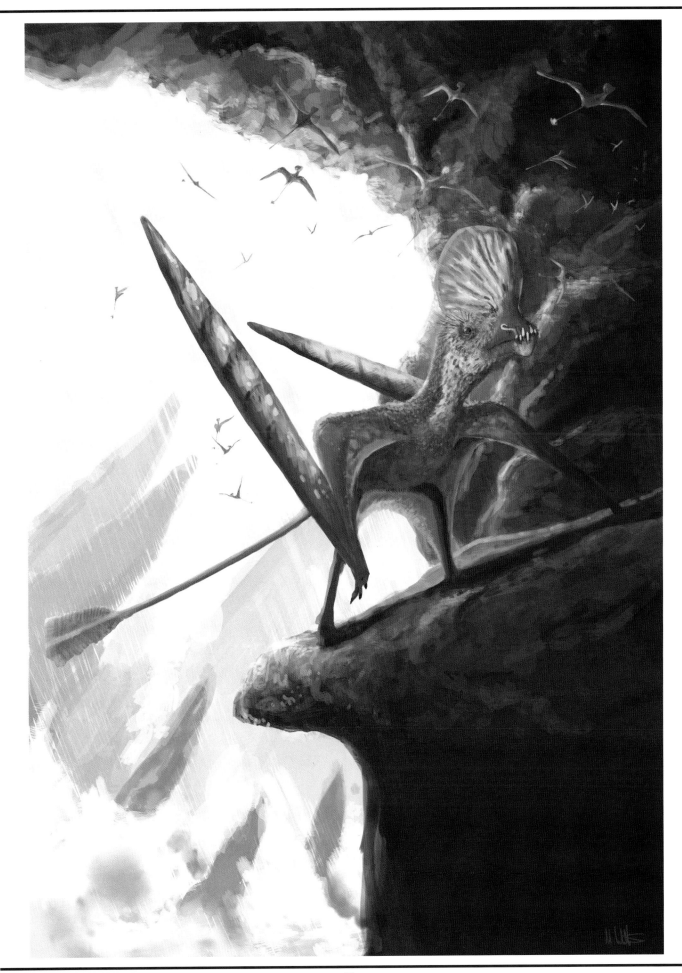

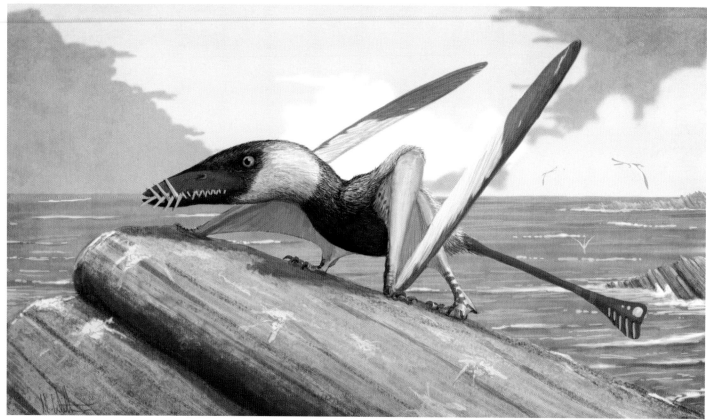

Dorygnathus banthensis at the coast
Early Jurassic (Toarcian), Germany. (2014)

adept aerial insectivore it likely was. Details of the *Anurognathus* wing skeleton indicate it was a highly manoeuvrable flier able to out-Top Gun nimble midges and other flying insects. Note that the prey here is deliberately shown as being small. We often depict fossil insectivores chasing dragonflies and other large, tough prey, but modern ecological analogues suggest these are rarer quarry than much smaller insects. Unpublished studies by Mike Habib and myself suggest *Anurognathus* was adapted for eating prey best measured in millimetres, and this informed my depiction of this hunting scene. The image on page 39 shows *Anurognathus* at the other end of the activity spectrum, at rest in a posture typical of anurognathid fossil remains. Pterosaur expert Christopher Bennett has proposed that these pterosaurs adopted this compact shape to hide and sequester themselves away, perhaps with cryptic colouration to aid their camouflage.

One of the strangest early pterosaurs, the Triassic species *Caviramus schesaplanensis*, is featured on page 41. Pterosaurs are known for being an anatomically 'extreme' group of creatures, and this animal represents one of their earliest dabblings with particularly unusual anatomy. *Caviramus* is broadly characterised by a set of multicusped teeth that are so tightly packed into the jaw that they overlap each other; a heavyset, powerfully muscled skull with a large cranial crest, and extremely long, slender wing bones. It's a challenging species to restore because many of these features oppose typical pterosaurian characteristics, such as their lightweight skull musculature and huge, bulging forelimbs. The sprawling, lanky arms and long hindlimbs make *Caviramus* appear especially 'leggy' among Triassic forms and, with the toothy skull and long tail, suggest it must've looked particularly spidery in life. I like to think that, if *Caviramus* were around today, it'd be the sort of animal we'd involve in creepy folklore.

A more familiar early pterosaur is shown above in the form of the Jurassic species *Dorygnathus banthensis*. But while the anatomy of this species is more typical, some aspects of this reconstruction aren't. In particular, the claws of the hands are shown as being retracted, like those of a cat. This is based on research I published in 2015 on 'antungual sesamoids', small, round bones found behind the claws of some pterosaur digits. These bones are situated in such a place that they likely aided or controlled the extension of pterosaur claws, perhaps as a means to help keep them sharp when walking on the ground. *Dorygnathus* only possesses these features on its hands, but other pterosaurs (including one we'll meet on page 50) had them on all walking digits.

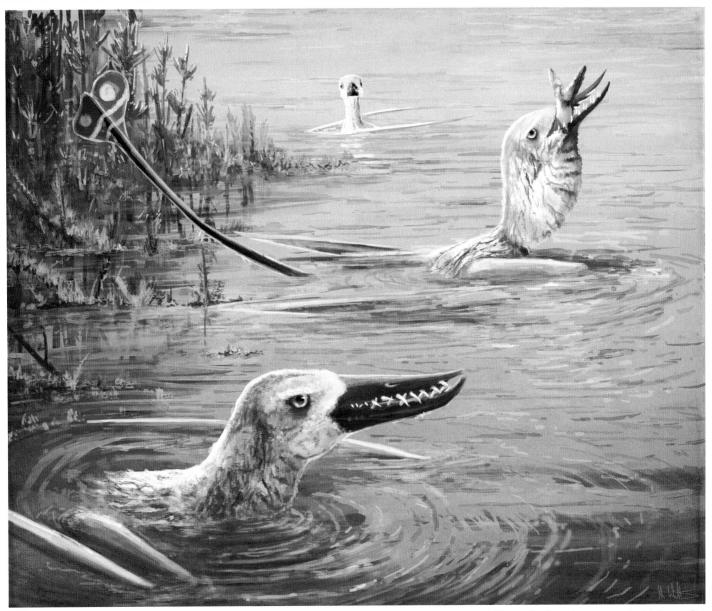

Rhamphorhynchus muensteri takes a dip
Late Jurassic (Tithonian), Germany. (2016)

Another Jurassic species, *Rhamphorhynchus muensteri*, is shown above. This animal is depicted in the floating posture predicted by my colleagues David Hone and Donald Henderson using computer models of pterosaur bodies and 'digital water'. This method has been employed to see how strangely shaped dinosaurs and modern giraffes might float (giraffes are extremely water shy, so it's just easier to understand their swimming capacity using computers. No, really.), and it seems to return accurate predictions of floating postures. Pterosaurs are far more front heavy than birds and likely floated in a fashion typical of most tetrapods, with their heads only just above the water surface. Many pterosaurs seem too front heavy to have been entirely comfortable resting the water surface, but experiments suggest the long tail and body of *Rhamphorhynchus* weighed their back ends down enough to give it a relatively stable floating posture. I took that as impetus to show three (differently aged) animals foraging at the water surface here. The resulting image is not great for showing what *Rhamphorhynchus* looked like, but obscuring much of their anatomy in water aids their portrayal as once living, breathing animals. Most sightings of modern wildlife are imperfect in one way or another, and I found painting these partly-seen floating pterosaurs gave a sense of witnessing them in life rather than drawing from imagination. The middle animal in this scene is swallowing a fish of a size known to have been eaten, whole, by a famous *Rhamphorhynchus* specimen - that bulging throat is the only way such substantial prey could enter its stomach.

Our last pterosaur painting (for now) features the Jurassic pterodactyloid *Pterodactylus antiquus*. After more than two centuries of research on this animal, we have a pretty good understanding of its palaeobiology. This includes an idea of its growth regime, which is depicted in the painting above. A short-faced, überfluffed neonate is seen in the foreground, its tiny size stressed by the mayflies hiding in the margins of the image. Longer-necked and more elaborately-crested juveniles are in the middle distance, and a fully fledged, tall-crested, 1 m wingspan adult takes the focus centre-right of the image. This animal is engaging in another activity inspired by local bird watching: paddling in pools of water to bring curious invertebrates to the surface. Many species of gulls use this strategy to find food, although the version depicted here is 'pterosaurified' in that the arms are being employed instead of the legs. I'm quite a fan of the idea

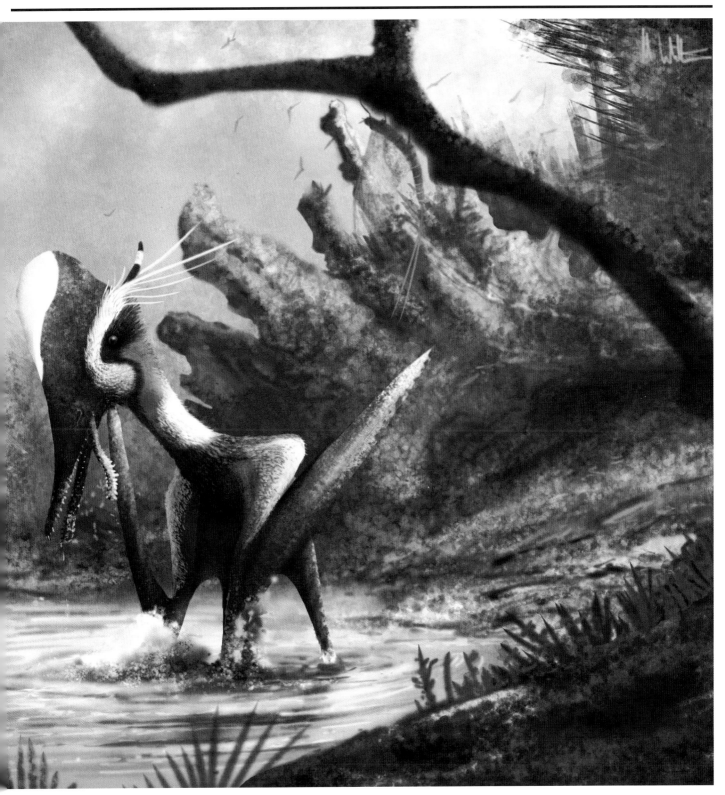

Differently aged individuals of *Pterodactylus antiquus* paddle around a stream
Late Jurassic (Tithonian), Germany. (2011, revised 2015)

that pterosaurs spent much of their time foraging using these fairly mundane, familiar strategies rather the more adventurous, dynamic behaviours we often see depicted in some artwork and proposed in far-reaching scientific papers. Grubbing for worms isn't glamorous, but I'm sure it worked for a large number of pterosaur species.

Mesozoic synapsids: coming of age

As a child, I found Mesozoic mammals and their ancestors to be the beigest of all fossil vertebrates. They were always shown as small, shrew- or rodent-like things, almost always awkward in form and coloured uniform brown, and of no challenge whatsoever to my interest in giant reptiles. Yeah, sure, they 'won' the Mesozoic in the end, but so did the Ewoks at the end of *Return of the Jedi*. And no-one likes Ewoks.

But these animals are slow burners: once you get beyond the age where only giant, sharped-toothed reptiles or horned-faced space cattle (p. 68) are considered worthy of your time, the details of mammalian evolution become fascinating. This is especially so because new fossil material is showing us what Mesozoic synapsids were really like. While the 'ancient shrew' concept remains true for a number of taxa, several lineages are known to have developed adaptations for digging, gliding, swimming and even bullying small dinosaurs. What's more, palaeoartistic interpretations of long extinct mammaliaforms have moved on a lot in recent years, decking out Mesozoic

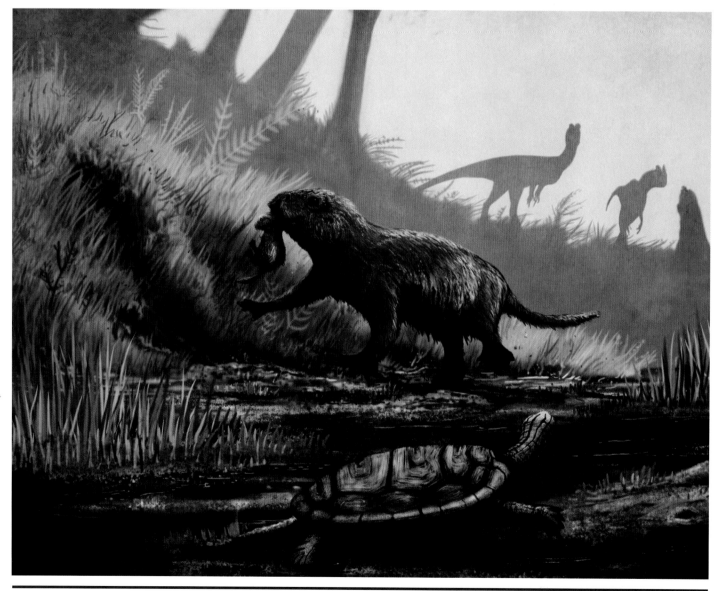

Kayentatherium wellesi alongside *Kayentachelys aprix*
Early Jurassic (Sinemurian), USA. (2015)

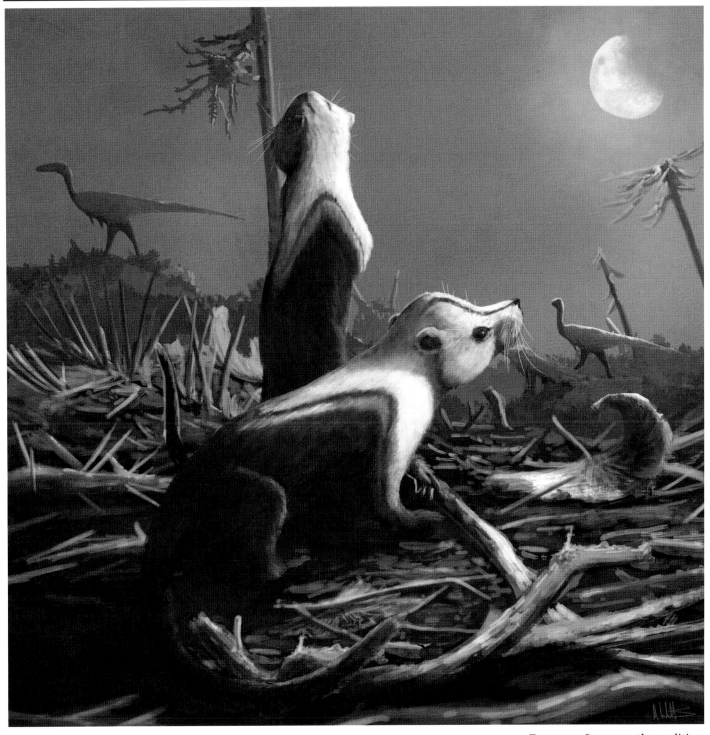

Two wary *Stereognathus ooliticus*
Middle Jurassic (Bathonian), UK. (2015)

species with healthy amounts of soft-tissue, fur and colour schemes that aren't just uniform brown. My own forays into Mesozoic synapsid art are limited, but they're a subject I'd gladly revisit for future projects.

Two of my paintings of Mesozoic synapsids feature tritylodonts. These are not mammaliaforms, but close cynodont relatives that are extremely mammal-like in many aspects of their anatomy. My paintings of these herbivorous species show the extreme ends of their anatomy: the large, heavyset *Kayentatherium wellesi* (opposite) and a smaller form meant to be *Stereognathus ooliticus* (above). Because *Stereognathus* is very poorly known, this painting really just shows a small, generic tritylodont, mainly based on the better known taxon *Oligokyphus*.

Kayentatherium is thought to have been a powerful

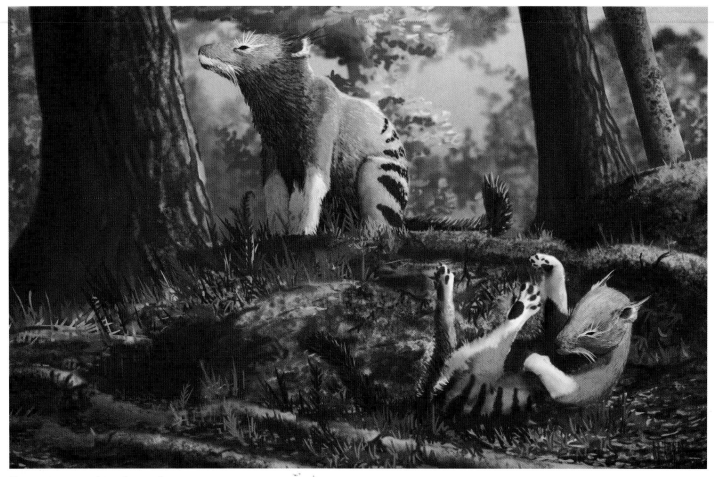

Repenomamus giganticus at home
Early Cretaceous (Barremian-Aptian), China. (2015)

animal: over a metre long, it was well adapted for digging and some recent studies have suggested it was semi-aquatic. Both of these behaviours informed this painting, a scar in the riverbank indicating an entrance to an elevated burrow, and the wet fur and webbed feet of the *Kayentatherium* being obvious indications of aquatic habits. There's something of beaver or otter influence to the face of the *Kayentatherium* too, a generous layer of soft-tissues creating a rounded, smooth appearance ideal for streamlined aquatic locomotion. This animal is also shown carrying its offspring. We mammals tend to have heightened parenting instincts, and I've speculated here that these behaviours had origins outside of Mammalia itself. As a large creature, there seemed little need to depict it scampering around - in the fashion of classic Mesozoic mammaliaform art - under the cover of night.

A nocturnal scenario has been depicted for *Stereognathus* however, this making sense because it was much smaller, more vulnerable animal. This image really is a throwback to typical Mesozoic mammaliaform art: two small furry animals skulking around the undergrowth while predatory reptiles patrol the distance. This is my favourite image of this set because the sense of lighting and scale seem to work - never something to be taken for granted. As with the *Kayentatherium*, the animals here are very 'mammalian' in appearance down the possession of ear pinnae and large whiskers. It's not clear from the fossil record when such features developed, but given the 'mammaliness' of the rest of the skeleton they do not seem out of place. The colouration of the *Stereognathus* is a deliberate effort to avoid shades of brown and produce a more interesting colour scheme. Although consisting of only three major colours (we mammals are often pretty dull, after all), I've attempted to give these animals a relatively high contrast, striking appearance. It seems 'striking' is often confused with 'colourful' when it comes to depicting fossil animals in 'interesting' ways, but modern animals show that they can be attractive, intricate-looking species without brilliant or vibrant colours. They do this through juxtaposing contrasting tones. Palaeoartists often default to bright, even garish colours to make their animals appear engaging, but it might be that high-contrast patterning is a better supported way to create arresting but believable restorations.

Moving on to the mammaliaforms, the image opposite shows the famous eutriconodont *Repenomamus giganticus*, a large (badger-sized), heavyset Cretaceous species well known for its dinosaurivory. An attempt was made here to move *Repenomamus* away from its near universal depiction as a bloodied dinosaur killer: it surely wasn't slaughtering dinosaurs all the time! Instead, I've depicted a pair of individuals hanging out around their forest burrow (this is another mammaliaform with possible digging adaptations) and one rolling around on the floor like a playful cat or dog. There's no specific reason in my mind for the rolling behaviour: the animal might be scratching itself, shuffling into a more comfortable pose, or simply messing around, but it seemed like a very mammalian trait to depict and aids my goal of showing *Repenomamus* as something more than a vicious predator. Elaborations of fur, including a mane on one individual, generally thick coats, fluffy tails and ear tufts are also featured. Recently discovered eutriconodont fossils demonstrate that Mesozoic mammal fur was no more uniform across their bodies than it is in modern species, and suggests we should be careful not to depict our ancestors with unvarying, short fuzz over their entire bodies.

Morganucodon watsoni (below) rounds up this set of mammal-like species from the Age of Reptiles. Morganucodontans are the quintessential Mesozoic mammaliaforms as, for a long time, they were the only Mesozoic mammaliaforms known from more than just skull fragments and teeth. *Morganucodon* and its kin are some of the most basal mammaliaforms known, but their skeletons are basically mammalian in function, if not entirely in form. It's difficult to rationalise their life appearance as being dissimilar to a modern rodent or shrew. The environment occupied by *Morganucodon* is shown in detail in this painting, the setting being karstic limestones dotted with remains of rhynchocephalians (members of the tuatara lineage), while forest fires rage in the background.

Morganucodon watsoni **forages for spiders**
Late Triassic/Early Jurassic, UK. (2014, revised 2015)

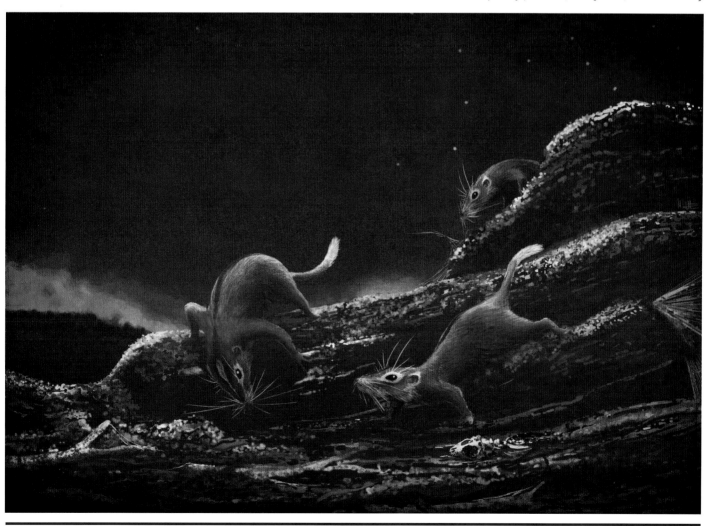

Rethinking *Dimorphodon*

The 'D'-shaped head, long limbs, short wings and robust skeleton of *Dimorphodon macronyx* make it one of the most identifiable and charismatic of pterosaurs. *Dimorphodon* is one of my favourite fossil animals and I sometimes wonder if it would have make a good pet. I've generally concluded that a raven-sized animal which can fly, climb and run with equal aptitude and answer restraining hands with inch-long fangs is not an ideal recipe for easy animal ownership.

I've illustrated *Dimorphodon* many times because it's proven an interesting research subject as much as a fun animal to visualise. Our fossil material of *Dimorphodon* is relatively good and much can be deduced about its lifestyle, functional anatomy and appearance. Much of my *Dimorphodon* artwork reflects research into the terrestrial habits of this animal. Several studies, including calculations performed in my PhD, indicate that *Dimorphodon* was a relatively heavyset creature, its wings being a little smaller than predicted for a pterosaur of its mass. Subsequent flight analyses have shown *Dimorphodon* was less glide efficient than comparably sized pterosaurs, and also burdened with elevated flapping power requirements. There are no reasons to think it was flightless, but this was probably not a pterosaur which flew as routinely, or for as long,

Dimorphodon macronyx outfoxes Sarcosaurus woodi
Early Jurassic (Sinemurian), UK. (2011, revised 2015)

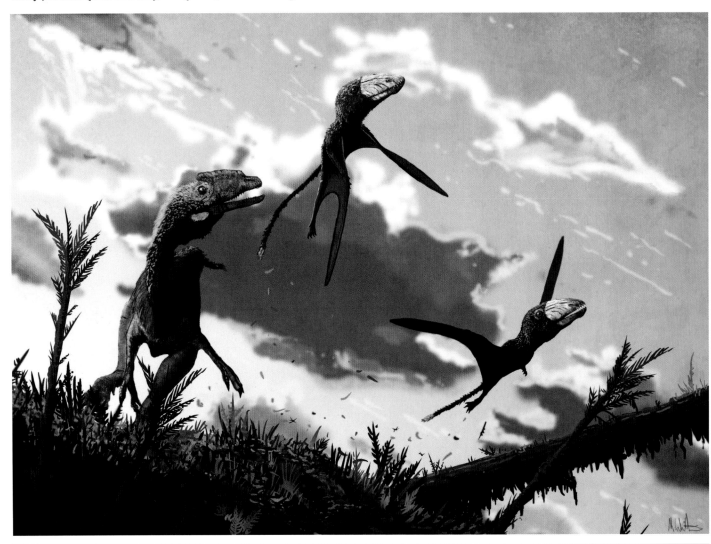

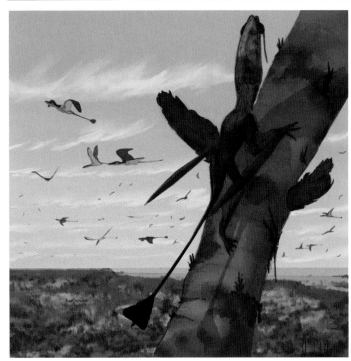
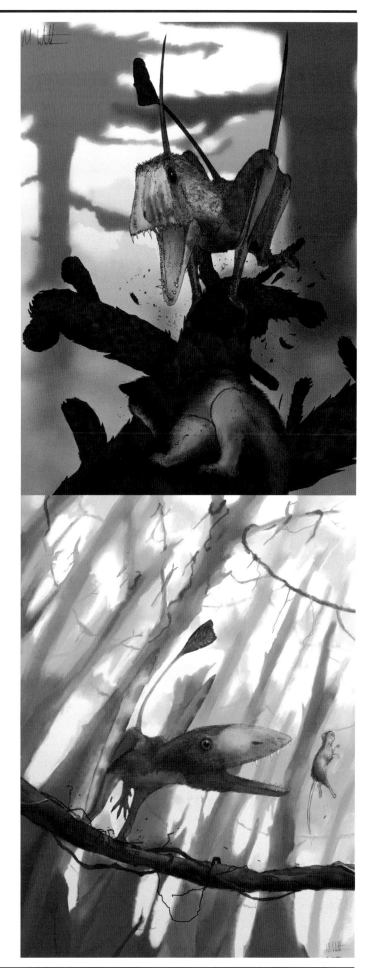

Apparently, I really, really like illustrating *Dimorphodon* predatory behaviour, having done so repeatedly over the years. (Clockwise from top: image from 2008, 2008 again, and 2011)

as other species. Flight might have been a means to escape danger (opposite) or reserved for journeys too arduous to undertake on foot. Perhaps as compensation for its limited flight capacity, several features of *Dimorphodon* anatomy indicate elevated terrestrial competency. These include joints indicative of fully upright limb postures, potentially retractable claws on all walking digits, equable limb proportions and robust limb bones, and jaws better suited to eating insects and small tetrapods than fish or squid. This theme has run through much of my artwork of this creature, and I've almost developed my own trope with the number of '*Dimorphodon* in pursuit of small tetrapod' images I've produced (this page and overleaf).

Breaking this mould in 2015 was an image showing multiple *Dimorphodon* around the coastlines of their Jurassic archipelago home (p. 54-55). This privately commissioned piece was refreshing to put together, it being a welcome change to paint *Dimorphodon* in a less dynamic pose (my favourites are the sitting animals) but also for the chance of using colour and setting to portray palaeontological hypotheses. Here, the darkly-coloured *Dimorphodon* look more at home in the greens and browns of the woodland setting than they do over the aquamarine water, a deliberate nod to the assumption that this species was more suited to a terrestrial existence than a marine one.

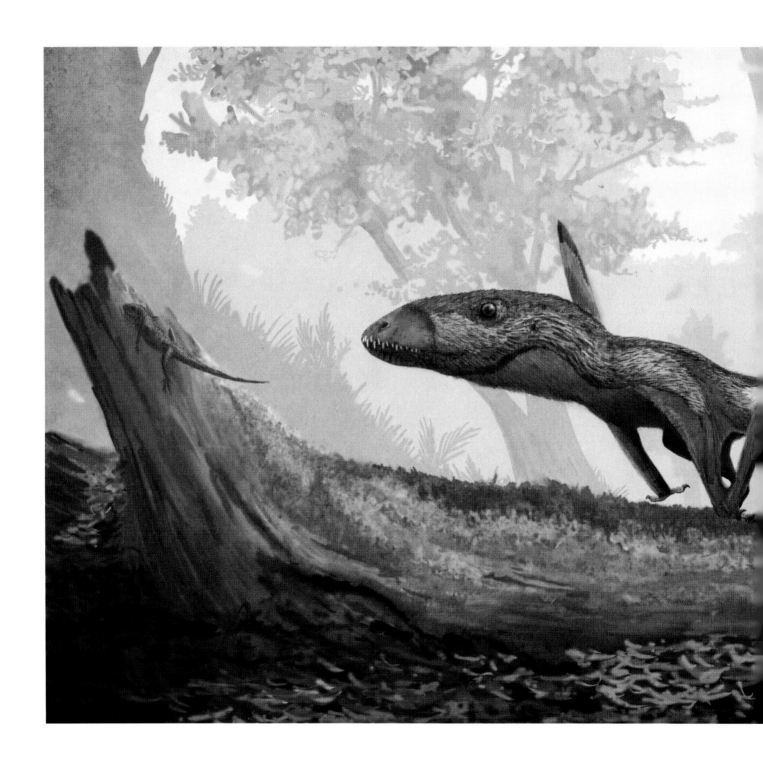

Left: *Dimorphodon macronyx* chases a sphenodontian
Early Jurassic (Sinemurian), UK. (2015)

Overleaf: *Dimorphodon macronyx* overlooking Jurassic islands
Early Jurassic (Sinemurian), UK. (2015)

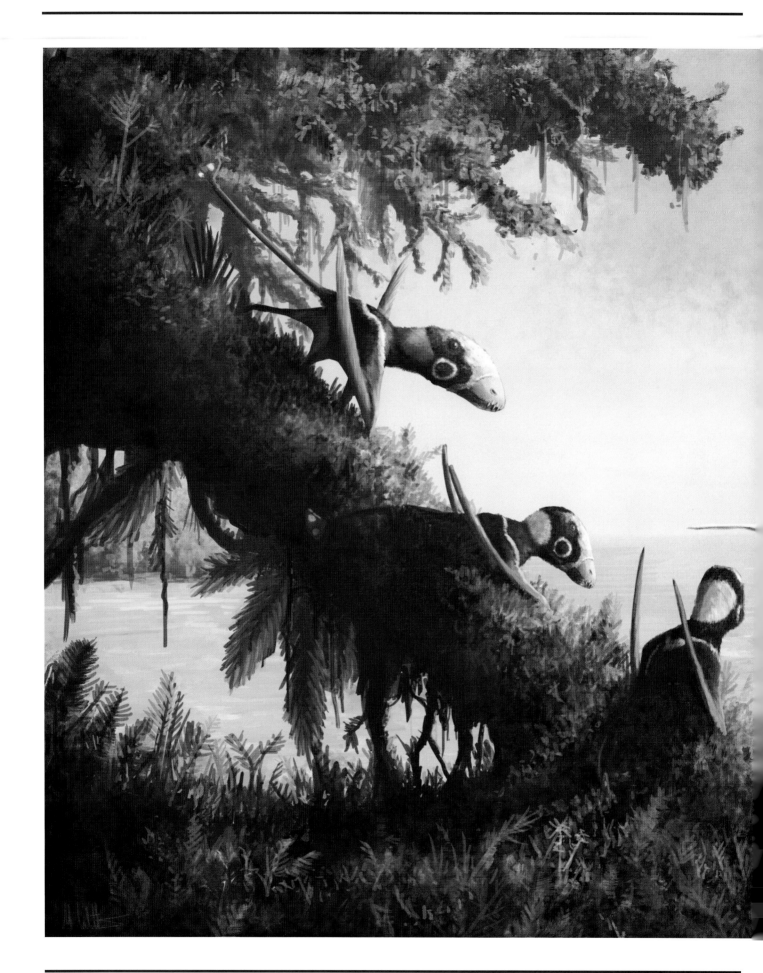

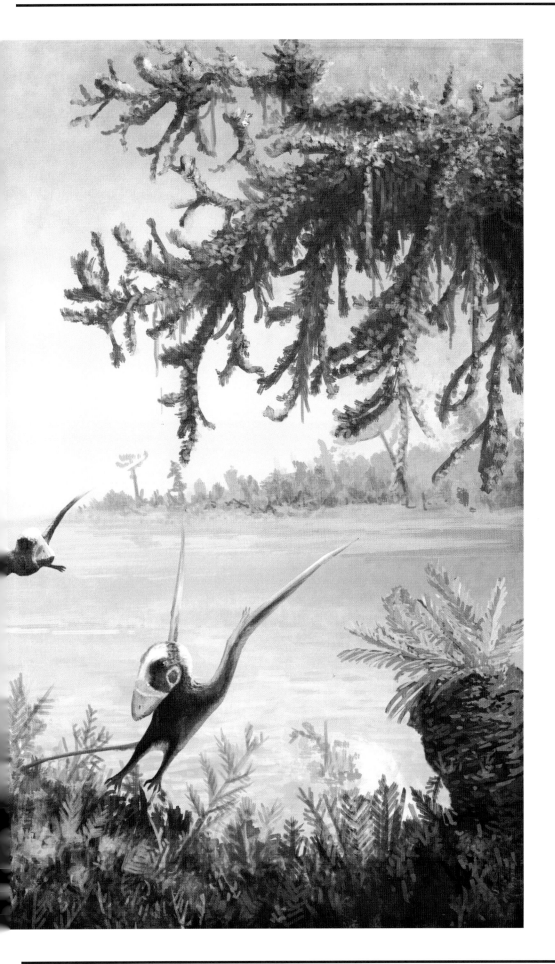

River masters

River ecosystems of the Mesozoic would seem both familiar and alien to our modern eyes. For all the relatively recognisable fish and crocodile-like creatures, there were also long-snouted, piscivorous dinosaurs and freshwater 'marine' reptiles. Even those lineages we think we know, like Crocodyliformes, threw in the odd curveball by adopting strange anatomies or sizes well beyond anything we experience today.

Some of the most unexpected creatures we might encounter in a Cretaceous river are leptocleidid plesiosaurs - and yes, that's the same 'plesiosaurs' which are otherwise categorised as marine reptiles. Leptocleidid fossils are unusual for often occurring in freshwater or brackish sediments and this is thought to reflect a preference to living away from open marine environments. Morphologically, leptocleidids were fairly generalised in form without the long necks or enormous heads characteristic of certain other plesiosaurs, and they might be best interpreted as unspecialised predators of fish and other swimming freshwater animals. In my leptocleidid painting, below, I've tried to emphasise their freshwater habits with some unusual choices for plesiosaur appearance. For instance, their skin is mottled green and has a rough, crenulated texture, a look inspired by snapping turtles. This would reduce their hydrodynamic efficiency, but would aid their chances of remaining undetected by prey in vegetation-choked lakes and rivers.

Below: Mother and calf *Leptocleidus superstes* explore a river inlet
Early Cretaceous (Barremian), UK. (2013, revised 2015)

Opposite: *Anteophthalmosuchus hooleyi* strikes at adult and juvenile *Hypsilophodon foxii*
Early Cretaceous (Barremian), UK. (2014, revised 2015)

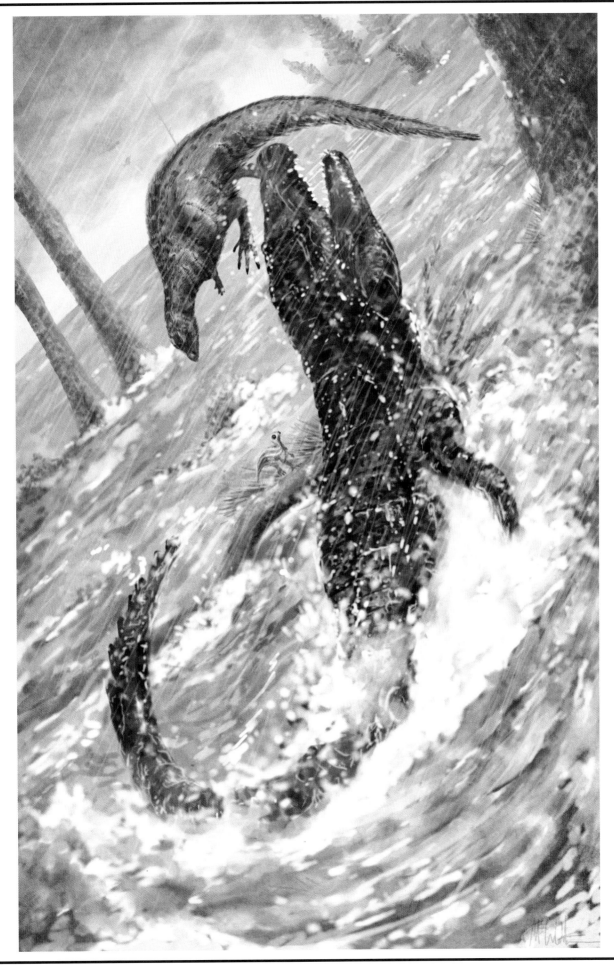

Crocodyliformes, the lineage containing our modern crocodylians, thrived during the Age of Reptiles. Mesozoic Crocodyliformes are famous for developing into a number of terrestrial and marine animals almost unrecognisable against our modern concepts of crocodylians, but they also established strongholds in the semiaquatic realm that they still hold today. These species were crocodile-like in general form, although they possess a number of anatomical differences from modern croc species which would be obvious in life. For instance, the goniopholidid *Anteophthalmosuchus hooleyi* (p. 57) had a simple, double row of bony armour along its back, long forelimbs, as well as eyes that faced forwards, which probably provided some degree of binocular vision. This broad-snouted form was almost certainly a predator of relatively large fish and unwary terrestrial animals, such as smaller dinosaurs. *Koumpiodontosuchus aprosdokiti* (right) also had a similarly simple armour arrangement, but was a much smaller animal that likely dined on hard-shelled invertebrate prey, using button-shaped teeth at the back of its jaw to smash them to pieces.

One of the most famous Mesozoic Crocodyliformes is *Deinosuchus robustus*, a true crocodylian related to modern alligators and caiman. *Deinosuchus* is one of the Mesozoic 'supercrocs': a gigantic, well-armoured animal with a bite so powerful that its teeth were frequently cracked and broken from delivering crippling bites to struggling prey. Although often depicted as a dinosaur predator (a habit verified from several fossil finds), the majority of data suggests it actually mostly dined on large turtles (above). These were probably caught by swimming somewhat out to sea, the distribution of *Deinosuchus* fossils showing that this crocodylian occurred in nearshore regions as much, or even more, than in coastal rivers.

To our modern eyes, spinosaurid theropods like *Baryonyx walkeri* (overleaf) would be some of the

Above: *Deinosuchus robustus* attempts to eat a quiet meal at a family restaurant
Late Cretaceous (Campanian), USA. (2016)

Below: *Koumpiodontosuchus aprosdokiti* predates *Viviparous cariniferous*
Early Cretaceous (Barremian), UK. (2014, revised 2015)

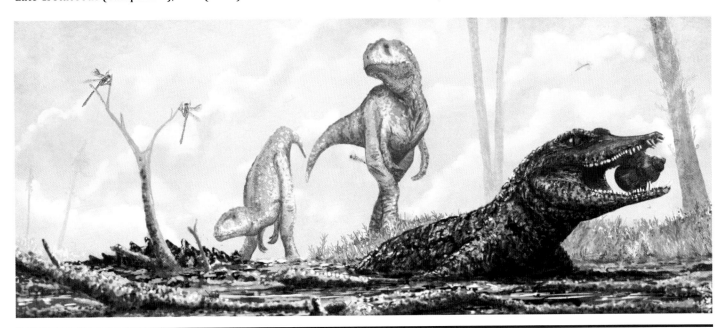

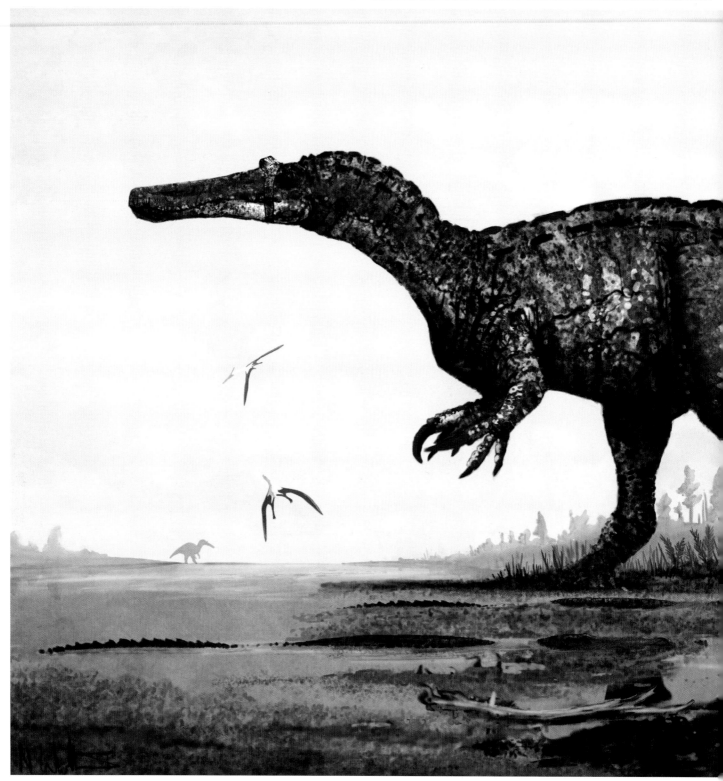

most startling Mesozoic river creatures. Indeed, they were surprising enough as fossil discoveries. *Baryonyx* was the first spinosaurid to be known from more than scraps of bone, and the long-snouted, big clawed appearance of this animal caused much excitement among palaeontologists in the 1980s. I am just old enough to have witnessed the first treatments of this fish-eating dinosaur in my childhood dinosaur books, and recall being amazed at just how unusual it was against more familiar theropods like *Tyrannosaurus* and *Allosaurus*. Spinosaurids are impressive animals, often being among the biggest predators in their ecosystems, and I wanted to capture some of that in my painting of *Baryonyx*. To emphasise its dominance, I set my *Baryonyx* among a group of goniopholidids. These were large predators in their own right, but probably still cleared aside when a mature *Baryonyx* wanted a fishing spot at the riverbank.

Baryonyx walkeri strides through a swamp of *Goniopholis*
Early Cretaceous (Barremian), UK. (2013, revised 2015)

Local heroes

Anyone who lives in the southern UK is within easy driving distance of historic dinosaur sites, including many which were pivotal to Victorian scientists developing those earliest interpretations of giant, extinct reptiles. My own home is not far from several Cretaceous dinosaur-bearing rock units on the Isle of Wight, these being the source of several relatively complete dinosaur specimens which informed historic interpretations of dinosaur shape and size. A very detailed picture of the UK's Lower Cretaceous reptile fauna has developed as research on these, and other Cretaceous rocks in Southern Britain has advanced. The record of these animals is not as complete as we might like - many species remain known from highly fragmentary fossils - but it contains a number of very famous taxa, along with lesser known species which are no less interesting.

One of the best known dinosaurs in the world was first found in the UK: *Iguanodon*. Discussing the convoluted history of this animal is well beyond our scope here, but it will suffice to say that UK rocks yield both the modern concept of *Iguanodon* (*I. bernissartensis*, below) and several animals tied into historic interpretations of this animal, such as *Barilium dawsoni* (right). I've long had issues about depictions of the *Iguanodon* thumb spike being used as a weapon. I remember a number of images from my youth where *Iguanodon* karate-

Iguanodon bernissartensis: **thumb wars**
Early Cretaceous (Barremian), UK. (2015)

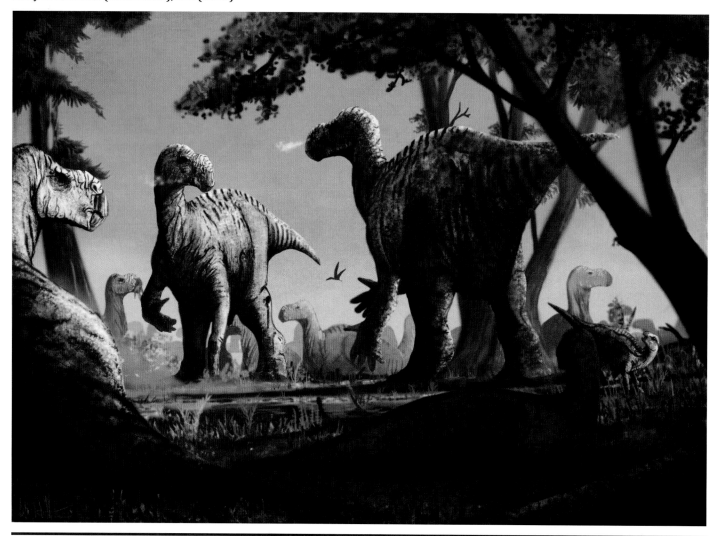

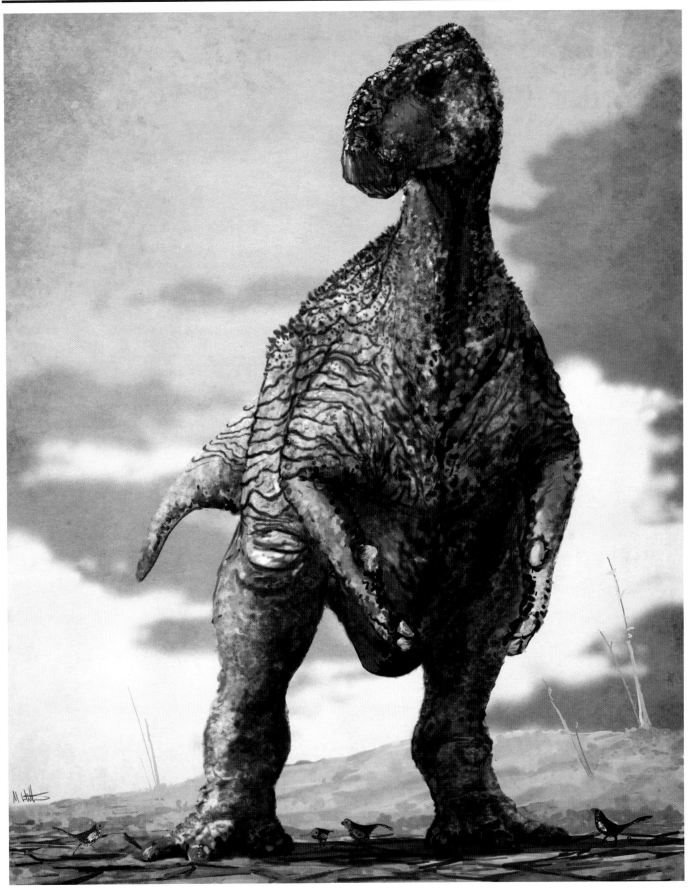

Barilium dawsoni looks tough in front of his friends
Early Cretaceous (Valanginian), UK. (2014, revised 2015)

chopped generic theropods in the neck, and never found them convincing even as a child. For the image on page 62, I've depicted a more brutal, but less functionally demanding alternative where they targeted their spikes at low-level soft-tissues and stabbed them repeatedly. In this scenario the spikes are being used intraspecifically, these animals meant to be gnarly, old individuals with scores to settle.

Like *I. bernissartensis*, *Barilium* is a large, chunky UK iguanodont, and may even be the 'original' *Iguanodon*. It was a heavily built animal with an especially big pelvic region and massive limbs. Its thumb spike, however, was a stunted, blunt structure quite unlike those we associate with these dinosaurs - this is an iguanodont who couldn't really give a 'thumbs up'. It's easy to forget how large the big iguanodonts were, especially with dinosaur sizes being so thoroughly eclipsed by sauropods, but standing alongside museum mounts of these animals reminds us that they were actually very big, powerful creatures. I wanted to convey the size and bulk of *Barilium* in my painting, choosing to fill most of the frame with it, using a low horizon line, and giving the skin a worn, weathered texture that recalls the skin of large modern animals. To heighten the sense of scale, I included a number of tiny, bird-like theropods based on the 'Ashdown maniraptoran' specimen: a solitary vertebra known from the same beds as *Barilium*. The result - I hope - is an iguanodont depiction with a good amount of heft to it.

Contrasting with these large, robust dinosaurs are the mid-sized, fleet-footed denizens of Britain's Early Cretaceous. These include an ornithomimosaur (below) and the historic species *Valdosaurus canaliculatus* (opposite). Ornithomimosaurs occur with some abundance at some fossil localities, the remains of adults intermixed with those of juveniles. This informed the populous composition of this scene. I depicted the feathered forelimbs of the running animal as pressed against the body instead of idly dangling. The arms of ostrich dinosaurs are very long, incapable of tight folding, and adorned with large feathers - potential nuisances to a long-legged, fast running animals. The pose used here was suggested for feathered dinosaurs by artist Emily Willoughby, who proposed this as a plausible alternative to the 'holding the shopping' arm pose often seen in theropod art.

A flock of Wessex Formation ornithomimosaurs forage in a marshland, while istiodactylid pterosaurs skulk about
Early Cretaceous (Barremian), UK. (2015)

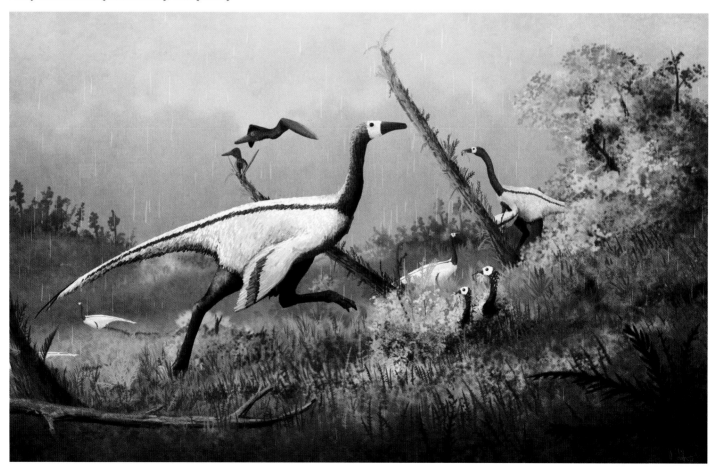

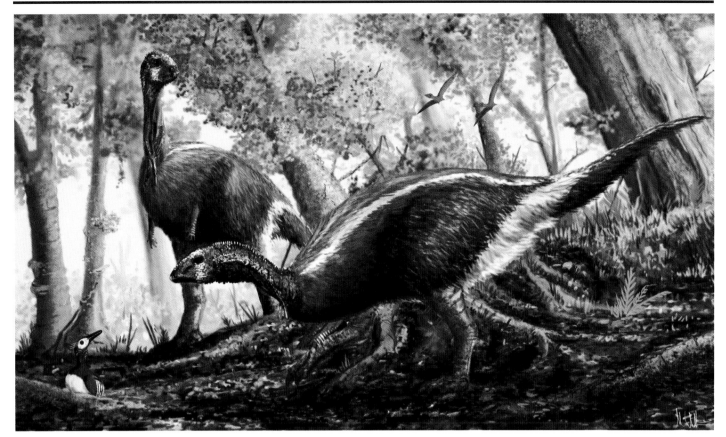

Above: *Valdosaurus canaliculatus* strolls through a Wealden wood, disturbing local residents
Early Cretaceous (Valanginian-Barremian), UK. (2014, revised 2015)

Overleaf: The lesser-seen Hastings Beds fauna: titanosaur *Haestasaurus becklesii*, possible carcharodontosaurian *Becklespinax altispinax*, eucryptodiran turtle *Hylaeochelys belli* and two azhdarchoid pterosaurs
Early Cretaceous (Valanginian), UK. (2014, revised 2015)

Valdosaurus is a dryosaurid, a group of iguanodonts adapted for fast running. Dryosaurids are rarely seen in palaeoart, and even more rarely seen doing anything other than escaping an attacker. In this quieter composition, *Valdosaurus* is given full focus and shows off the dryosaurid approach to fast running. Simply summarised, the forequarters were very small, while the hindlimbs were enormous, long and powerfully muscled: the two ends almost look like they belong to different animals. As well as featuring a rarely depicted animal, this image also showcases the lesser seen wooded setting of Britain's Early Cretaceous landscape. Many of the UK's lower Cretaceous rocks were deposited on large floodplain, and this backdrop forms the setting for virtually all palaeoart of this time. However, we know this floodplain was bordered by hills, marshlands, wooded areas and other habitats - we just don't see them used in art very often. I often try to set my artwork 'off the beaten track' in this way, having found that the geological settings of subject species often reveal interesting alternatives to 'open floodplain' settings so familiar to palaeoart audiences.

The subject of atypical scenes bring us to the last image in this set: a speculative reconstruction of the Hastings Beds reptile fauna. This image shows some of Britain's oldest Cretaceous dinosaurs, pterosaurs and turtles, all of which are poorly known and thus infrequently depicted in art. The animals (sauropod *Haestasaurus becklesii*, theropod *Becklespinax altispinax*, turtle *Hylaeochelys belli* and two azhdarchoid pterosaurs) are not precisely restored based on fossil remains because they are all known from handfuls (or less) of bones. Instead, this assemblage has largely been reconstructed by taxonomic proxy - close relatives are used as stand-ins to demonstrate what this fauna might have collectively resembled. Where possible, anatomical tweaks to the stand-ins have been made to better match the Hastings Beds material. I don't doubt that this image will date as we learn more about these animals - the only way is up as far as their fossil record goes - but I think there's value to these speculative images in demonstrating animals and landscapes outside of our better sampled, more familiar fossil subjects. There's more to be said on this approach - we'll come back to it later in the book.

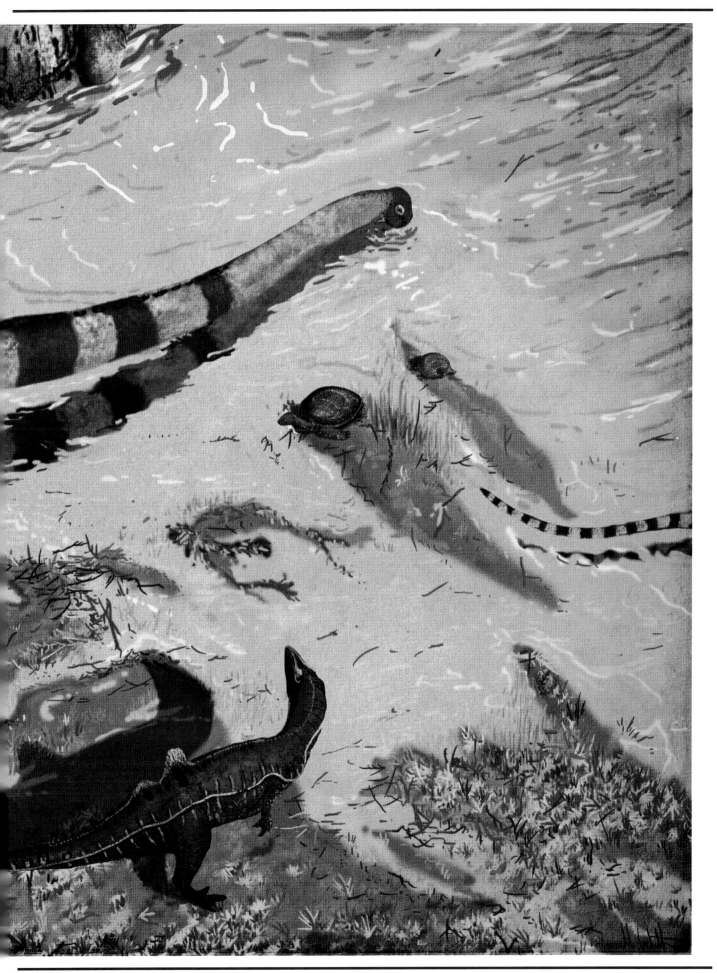

Controversial ceratopsians

Ceratopsians are probably the coolest looking dinosaurs of all. That's a hard won contest, but their massive, ornate skulls, stout bodies and powerful limbs make for a pretty awesome bauplan. Indeed, they're more reminiscent of science fiction creatures than real animals. I, for one, secretly suspect ceratopsians are not dinosaurs at all, but a tribe of reptilian war-cattle farmed by a master race of Giant Space Ants.

Because they look so interesting, horned dinosaurs are fantastic animals to restore, albeit ones that can be very unforgiving. I challenge anyone to not need at least a couple of goes at drawing their sweeping, spiky skull geometry in any given reconstruction. My forays into the world of ceratopsians often leave me with some explaining to do. I don't deliberately go out of my way to handle them in a controversial light: rather, they've simply been in the wrong place at the wrong time when I've been thinking more radically about prehistoric animal appearance and behaviour.

You don't get much more controversial than a horned dinosaur eating meat (below). Ceratopsians have numerous adaptations for herbivory, and there's no doubt that they obtained most of their nutrients from plant matter. But their strongly hooked beaks and huge, 'mega-serrated' dental batteries are strange among large herbivores in being adapted for scissor-like

Below: Scavenging *Styracosaurus albertensis*
Late Cretaceous (Campanian), Canada. (2007, revised 2015)

Opposite: *Protoceratops hellenikorhinus*, **the lesser seen** *Protoceratops* **species**
Late Cretaceous (Campanian), Mongolia. (2016)

Speculatively woolly ceratopsid *Pachyrhinosaurus perotorum*
Late Cretaceous (Maastrichtian), USA. (2012, revised 2015)

shearing rather than tearing and grinding, the approach used by most other animals that extensively chew plant food. This has been the source of some discussion among palaeontologists. One sensible conclusion is that ceratopsians ate lots of high-fibre plant matter, but some have wondered if it also allowed horned dinosaurs to turn their jaws to a non-vegetarian diet. Chewing carnivores also have a shearing dentition (cats being the best known example) and some researchers (most notably Gregory S. Paul) have interpreted ceratopsians as more omnivorous than herbivorous. This idea has gained greater traction with artists than scientists, but seems reasonable given that modern herbivores often take carnivorous turns to supplement their nutrient poor diets. Some, like hippos and pigs, have an alarming predilection for eating meat, sometimes even killing other animals to do so. There's no reason to think extinct herbivores would not show

Machairoceratops cronusi herd takes a bath, annoys a local crustacean
Late Cretaceous (Campanian), USA. (2016)

the same behavioural flexibility, especially if their foraging apparatus was exapted for ripping carcasses open and processing flesh.

Although not a contentious image itself, my rendering of *Protoceratops hellenikorhinus* (p. 69, this being the larger, more ornamented species of *Protoceratops* than the artistically dominant *P. andrewsi*) still required some explanation when it was published alongside a disputable

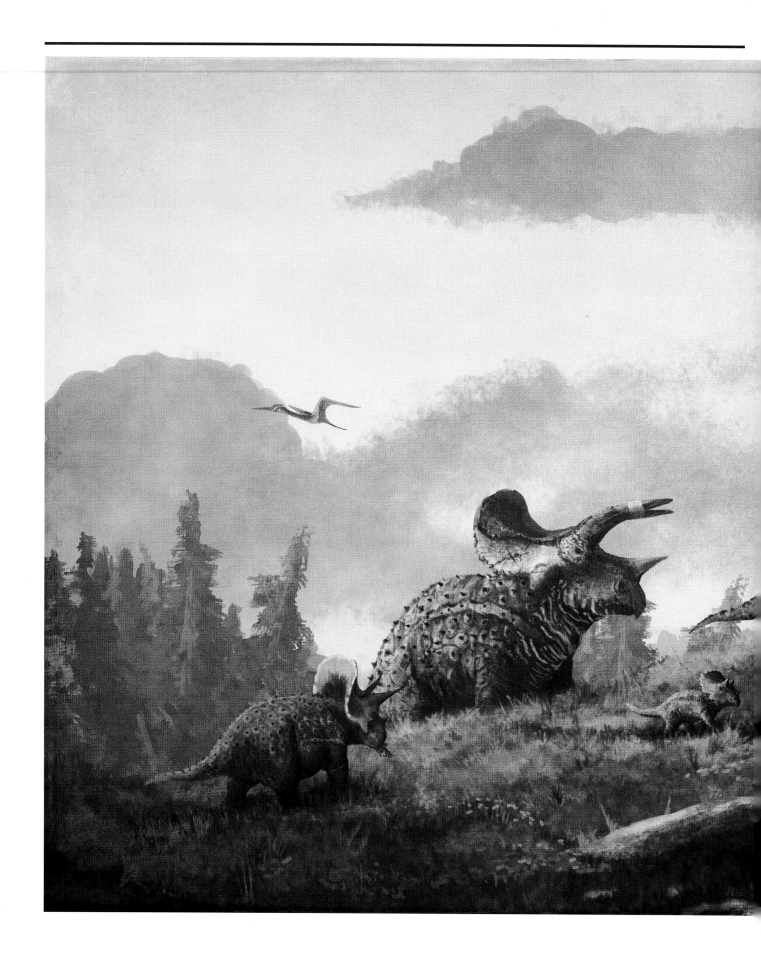

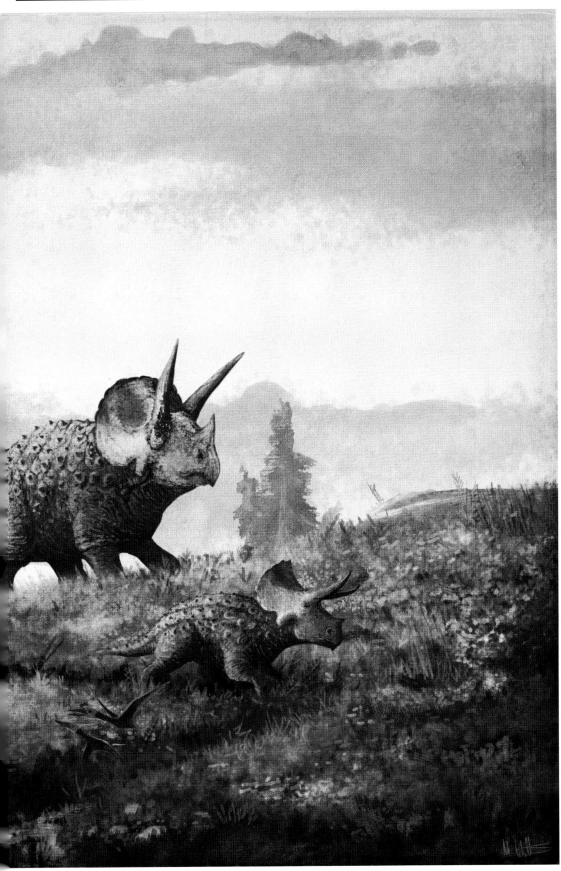

Triceratops horridus on the plains
Late Cretaceous (Maastrichtian), USA. (2015)

claim: that *Protoceratops* was *not* the source of the griffin legend. The idea that the griffin, a 6000 year-old Near Eastern chimera of a bird and lion, was based on *Protoceratops* fossils has been around since at least the 1990s and accepted by a number of scientific outlets. When interested in claims that griffin iconography were some the first attempts at palaeoart, I found myself looking into the rationale behind this proposal and came away unconvinced. Details of griffin chronology and iconography, their descriptions in ancient texts, and specifics of *Protoceratops* anatomy and geography create a number of problems for this idea. I wanted to put these counterpoints on record at my blog, and rendered this painting of a reclining *P. hellenikorhinus* to accompany my arguments.

More overtly controversial is the rendering of the high latitude horned dinosaur *Pachyrhinosaurus perotorum* as a shaggy Mesozoic muskoxen (p. 70-71). This image was created shortly after the publication of *All Yesterdays*, a tome by John Conway *et al.* (2012) devoted to discussing informed speculation in palaeoart and an essential read for anyone interested in the artistic portrayal of extinct life. This picture was directly inspired by its promotion of 'reasoned speculation' in palaeoart. In this case, I reasoned that we have a lot of skin samples of horned dinosaurs, most of them showing scales, but modern animals demonstrate that what applies to the skin of one species in a given group, or a number of related species, does not apply to all. Ergo, we palaeoartists have to wonder how confident we can be about the rationale of transferring skin types between closely related fossil species. On the one hand, it's a sensible thing to do (and I'm not saying we shouldn't do it), but we can also never shake the possibility that we're way off target because so many exceptions to 'typical' integuments exist within animal groups (examples include woolly mammoths among elephants, naked-skinned humans among primates etc.). This image, then, is deliberately subversive, and shows what this dinosaur of relatively cold, damp, northern climes may have looked like if it bore filaments instead of scales. Note that the image is not entirely speculative: the facial integument of these animals shows the scalation pattern and tough, heavily keratinised nasal boss tissues predicted for *P. perotorum* from its skull texture. It seems the skin of horned dinosaur faces was tightly pressed to their skulls in some places, allowing us to predict specific integument types from their skull bone textures.

Not every horned dinosaur I've drawn is a magnet for controversy. The 2016 press release image I created for Eric Lund and Pat O'Connor's work on *Machairoceratops cronusi* plays things straight (p. 72-73), although we still included plenty of details to keep the image interesting. For instance, Eric suggested we use a coastal setting rather than just depicting the animal in an open clearing, and that the animals might be engaging in wallowing rather than standing around. The large number of animals allowed us to show variation in their posture and attitude, and I took inspiration from hissing geese when drawing the vocalising animal in the mid-distance - notice the tongue of this animal is lifted towards the front of the mouth. I also snuck in another homage to the work of Charles Knight here, the large dewlaps and spiny backs being references to his famous *Agathaumas* portrait.

The image of a *Triceratops horridus* family on pages 74-75 is also a non-controversial take on these animals, although its inclusion of modern ideas on growth stages and scalation means it differs from many images of this animal. We have good evidence that *Triceratops* skulls changed quite radically as they grew, and you can see this clearly in my painting: the large adults look very different to the juveniles. New data on *Triceratops* skin suggests it was unique among dinosaur integuments. Huge, polygonal scales with prominent central tubercles covered the back, while similarly large quadrangular scales covered the belly. This painting is one of my favourite images of recent times, it being one of my more accomplished works in a technical sense and being one of the few times my patience has lasted long enough to show more than one or two animals. It was fun to play around with the colours of the landscape, too, the latest Cretaceous being a time when flowering plants were abundant and low lying flowers were probably common in some areas. As with my other work on horned dinosaurs, I depicted the largest ceratopsians here with elaborate patterns on their faces and forequarters to enhance their intimidating skulls, and made deliberate efforts to make the big, dark patriarch look especially intimidating. Note the juvenile animal on the left is starting to differentiate from its sisters in adopting these more striking male features.

Hey Triassic, you so crazy

Above: The nocturnal habits of *Scleromochlus taylori* Late Triassic (Carnian), Scotland. (2014, revised 2015)

Overleaf: *Drepanosaurus unguicaudatus* rips a grub from a Triassic tree Late Triassic (Norian), Italy. (2015)

The greatest mass extinction of all time almost wiped out life immediately before the Mesozoic Era began. This left animals of the first Mesozoic period - the Triassic - to re-establish the natural world from an almost blank slate. The result was a period of evolutionary experimentation which not only saw the rise of familiar animals like dinosaurs, mammals, and pterosaurs, but also a string of highly unusual lineages. Many of these, it seems, were creatures that only thrived in Triassic conditions. As groups like dinosaurs became dominant towards the end of the Triassic and ecosystems re-established themselves fully, these lineages died off. But though short lived, this interval of evolution is one of the richest playgrounds for palaeoartists: some of the strangest and most singular animals ever lived in the Triassic, and attempting to restore them is as fun as it is challenging.

One of my favourite Triassic creatures is seen above:

Scleromochlus taylori. This small Scottish reptile is most famous for generally being considered the closest known relative of pterosaurs, and we rarely hear about it outside of this context. This is a shame, because this tiny, big eyed, long-legged desert-living creature is a fascinating species in its own right. *Scleromochlus* is interpreted as a fast runner or saltator (a creature which moves by jumping), is sometimes found preserved in small groups, perhaps reflecting gregarious habits, and had a powerful set of jaws with sharp, nipping teeth to crack open insect cuticles. I wanted to bring some of these conclusions to the fore in my image of this animal, showing a pair of them bounding over dunes in the cool air of a desert night. Because these animals are likely related to pterosaurs and dinosaurs, I've also adorned it with a mix of scales and short filaments. Possible scales are known from the backs of some *Scleromochlus* specimens, which are depicted here. However, both the pterosaur and

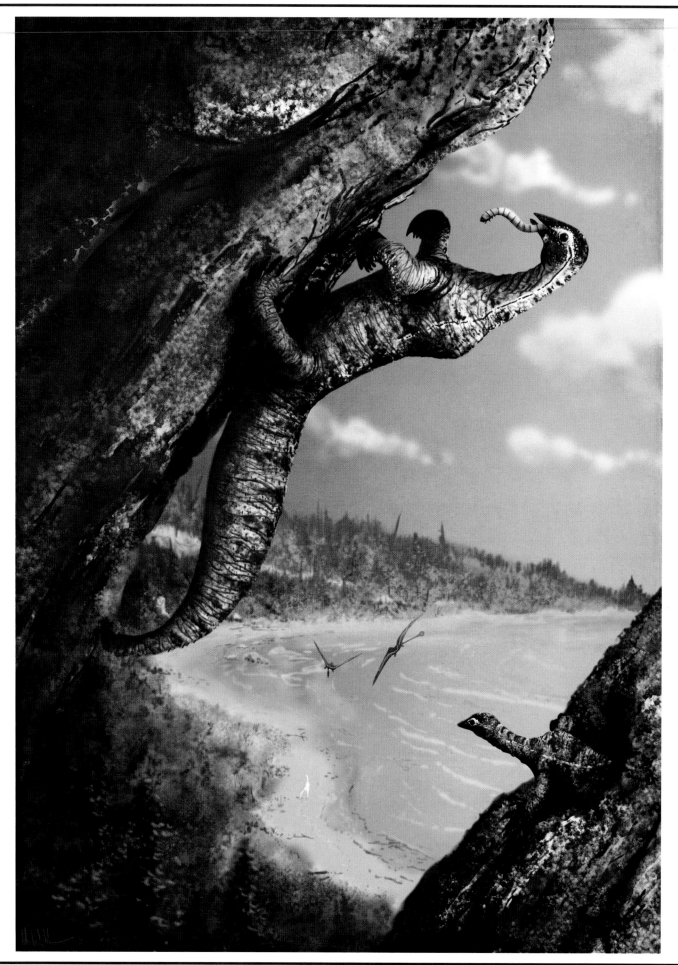

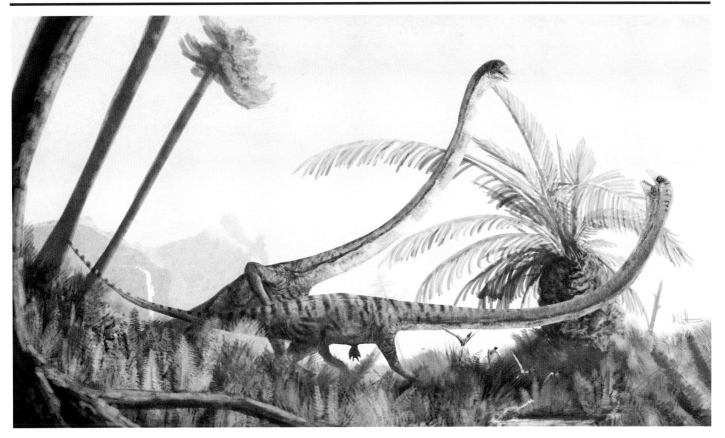

Above: Two *Tanystropheus longobardicus* settle their differences
Middle Triassic (Landinian), Italy. (2015)

Below: The bizarre hindlimb glider *Sharovipteryx mirabilis*
Middle Triassic (Landinian), Kyrgyzstan. (2015)

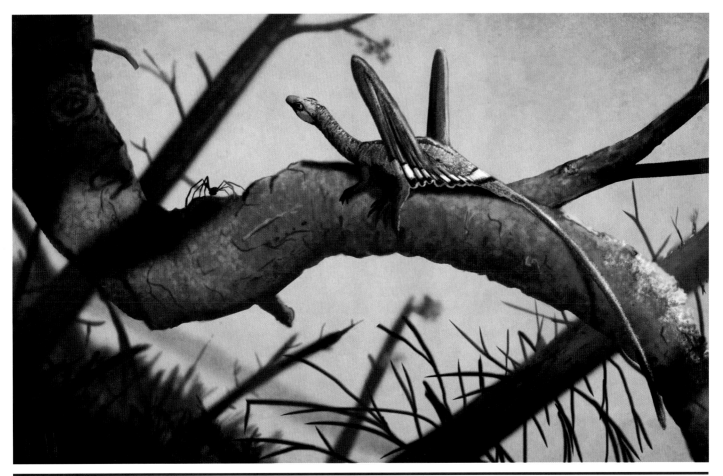

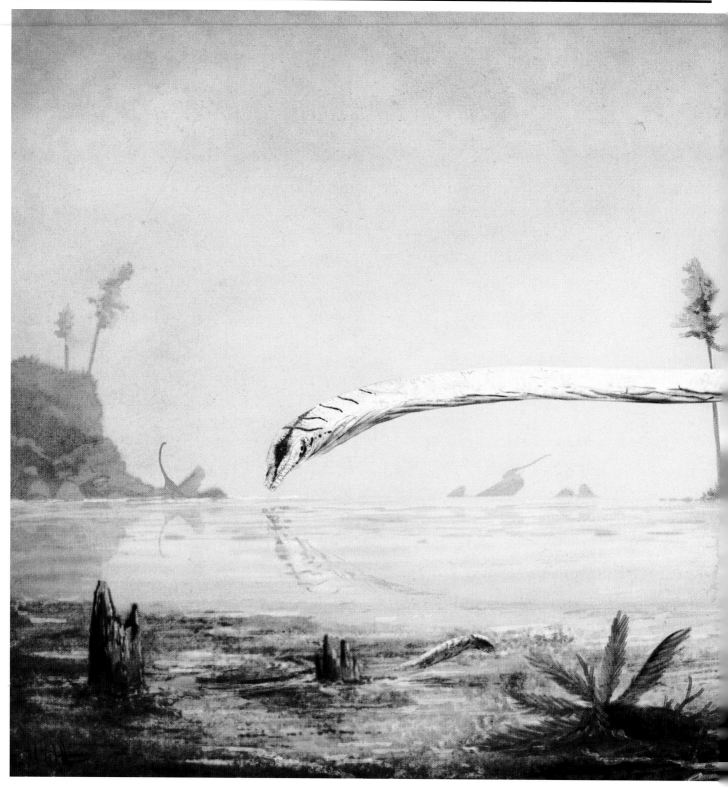

dinosaur relatives of *Scleromochlus* are known to mix scaly and filamentous integuments, so the rest of the animal was restored with filaments, in line with this.

Page 78 shows one of the nuttiest types of reptiles to ever evolve: *Drepanosaurus unguicaudatus*. Drepanosaurids don't look too weird when reconstructed - sort of like deep-bodied lizards - but their skeletons have the most left-field adaptations to climbing and digging you'll ever see. Need some extra grip? OK, make a flexible tail and shove a spike on the end. Want a strong arm? Transform the major bone of the forearm into a short, broad plate situated only at the elbow, and make up the rest of the forearm length from a wrist bone. Perhaps put a gigantic, trenchant claw on the index finger, but leave the rest untouched. Need strong shoulder muscles? Only chumps bulk up the shoulder blade: why not enlarge some vertebrae,

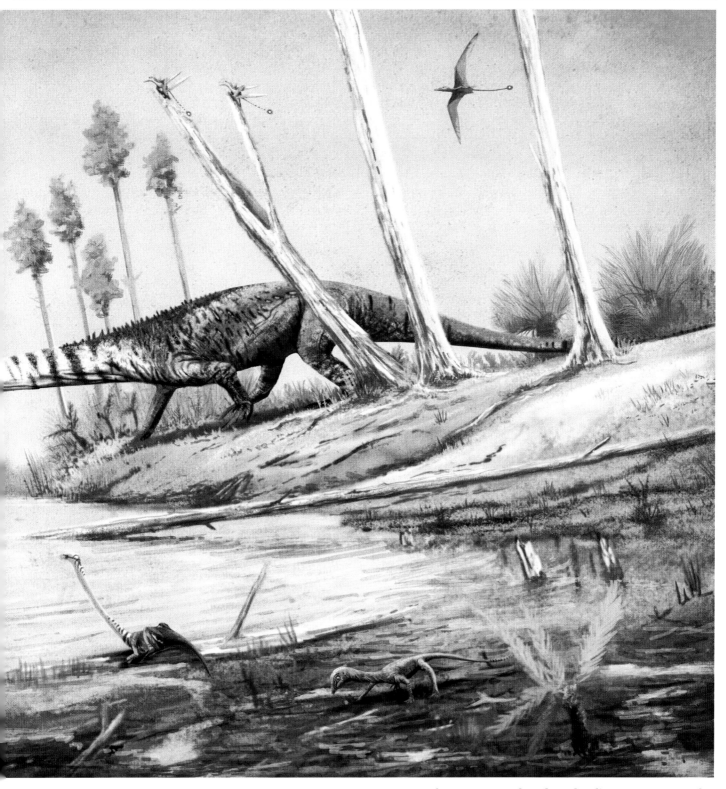

A large *Tanystropheus longobardicus* prepares a strike,
while other Triassic animals go about their business
Middle Triassic (Landinian), Italy. (2015)

fuse them together like those of a freakin' flying animal, and use those instead? And while we don't have the skull and neck of *Drepanosaurus* itself, those of its relatives are extremely slight and bird-like, because at this point using anything resembling a typical reptilian neck and head would just be stupid. It's the sort of animal that has to be seen to be believed, and one of those creatures which reminds us why palaeontology is such an fascinating science. My image of this animal shows two individuals climbing around trees, ripping into bark in pursuit of invertebrate prey. The inspiration for their blue colour came from a pair of blue-spotted tree monitors I still resist purchasing from a local pet shop (and the desire to see a drepanosaurid coloured something other than green).

A relative of *Drepanosaurus*, *Sharovipteryx mirabilis*, is featured on page 79. Its overall form is also quite lizard-like, until the length of the back legs is noticed. But unlike long-legged *Scleromochlus*, this was not a runner or saltator. Rather, those legs supported membranes for gliding - yes, the Triassic gave rise to an animal which flew using its legs. Experiments on the gliding potential of this animal suggest it flew with as much finesse as any modern glider, using its long tail and forelimbs to help steer itself between glide points. *Sharovipteryx* is typically depicted in flight, but in this image it is shown at rest, its leg membranes bunched up behind the over-long hindlimbs. This folding was inspired by the sole known *Sharovipteryx* fossil, which also has slightly fluttered leg membranes.

One of the best known Triassic oddballs is *Tanystropheus longobardicus*, a gigantic (up to 6 m long) reptile with a neck that represents half its body length (p. 79, 80-81). The lifestyle of this species has proved highly controversial among palaeontologists. Although it is universally agreed that *Tanystropheus* was a predator of small swimming animals, opinion is divided on whether it fished from the shoreline or hunted in water. We could spend pages discussing this, so I'll cut to the chase and state my agreement with those arguing for shore-based foraging. *Tanystropheus* anatomy - from basic proportions to details of bone structure - seem far better suited to a terrestrial or only partly aquatic lifestyle than one spent swimming after fish, and that long, lightened neck seems to have operated more like a simple crane than a strong, flexible aquatic foraging appendage. My images of this animal reflect this hypothesis. The first shows two *Tanystropheus* squabbling on a coastal plain, both bearing very 'terrestrial' colours. This image is really a reaction to other *Tanystropheus* art, including my own, where it is always shown in or next to large bodies of water - surely it did other things as well? A more traditional rendition of *Tanystropheus* foraging forms the second picture. Here, the neck is coloured white so as to disguise it from aquatic prey against the bright sky. The head and neck are deliberately held low, too: like a heron or egret stalking prey from the shore, I imagine this animal would move its jaws as close as possible to an intended victim before a strike, minimising the chance of the prey being startled by the sudden movement. In the background, several *Tanystropheus* have swum to far off rocks to obtain prey away from their competitors, and a selection of other Triassic animals (pterosaurs and short-necked protorosaurian reptiles) adorn closer areas.

The last of our strange Triassic creatures is also the least understood. For all their weirdness, the other animals mentioned here can at least be reliably plugged into the reptile tree somewhere. This is not the case for *Longisquama insignis* (right), however. This animal is known from the front half of a skeleton which has a bizarre collection of large soft-tissue 'fronds' projecting from its back. Several fossils of these soft-tissue structures are known which permit insight into their size and arrangement, but a complete skeleton of *Longisquama*, or even a well-preserved partial one, remains elusive. This animal is generally assumed to have looked a bit like a lizard in life - and that's the angle I've gone with here - but, as with all *Longisquama* restorations, the rear ends of the animals in this illustration are conjectural.

Whatever it is, and whatever it looked like, *Longisquama* was clearly a showy species and I've illustrated it here in a battle of flamboyance. The animals have climbed to the tops of branches to erect their plumes and prove their status to their neighbours. The principal animal in this scene is also waving, a nod to the sign language employed by some lizards (well known in pet lizard species, such as certain anoles and bearded dragons) to further communicate their status and intent.

**An early morning waving competition among *Longisquama insignis*
Middle Triassic (Landinian), Kyrgyzstan. (2015)**

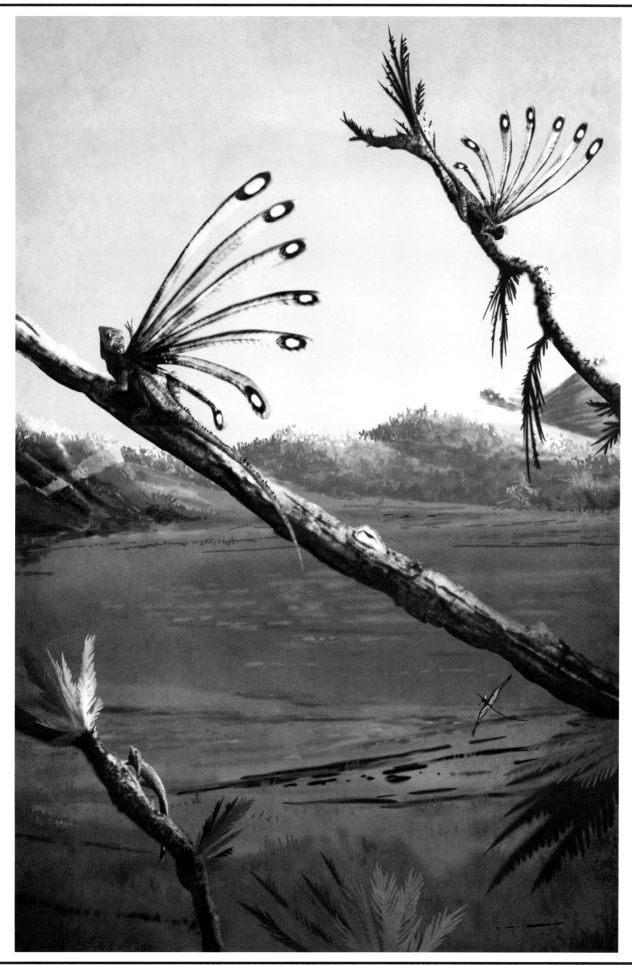

An accidental *Tyrannosaurus* fan

I have a love/hate relationship with *Tyrannosaurus rex*. Yes, it's the most famous dinosaur of all time. Yes, it was one of the most awesome predatory species to ever evolve. Yes, intense research interest in this animal has provided tremendous insight into dinosaur palaeobiology, and yes, we probably know more about it than almost any other Mesozoic dinosaur. But, yes, it's also an overly familiar, 'overexposed' dinosaurian celebrity, and the focus of so many books, exhibitions, documentaries, films and artworks that it's hard not to lament the fact that few other extinct species, or even groups of species, receive similar academic and creative treatment. I sometimes feel that *Tyrannosaurus* is 'done' as far as modern science goes, or at least so much more completely understood than other fossil animals that we might want to give it a break and check out some early archosauromorphs or something.

Of course, the fact that this book has a section dedicated to *Tyrannosaurus* exposes me as a hypocrite

A whimsical hillside, starring *Tyrannosaurus rex* and a fleet of moths
Late Cretaceous (Maastrichtian), USA. (2015, concept by Chidumebi Browne)

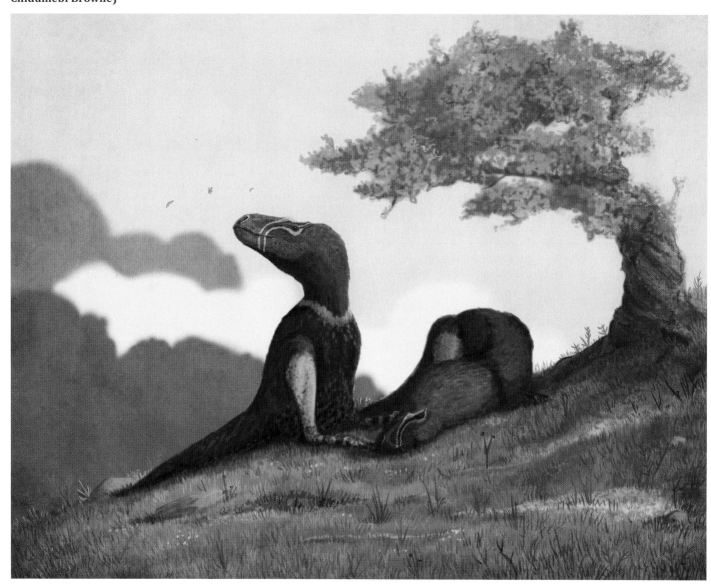

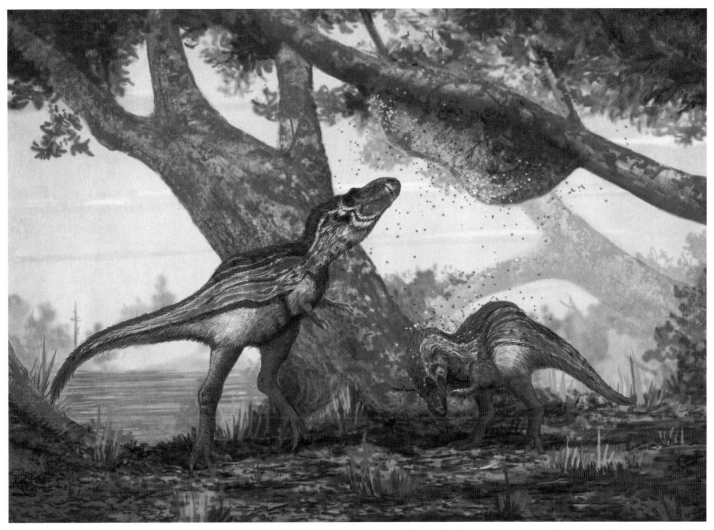

**Juvenile *Tyrannosaurus rex* take on a bee hive. Bees win.
Late Cretaceous (Maastrichtian), USA. 2015**

here. For all my moaning, *Tyrannosaurus* is tremendous fun to illustrate, and our keen interest in documenting its anatomy means we can restore it in detail. Illustrating *Tyrannosaurus* is a like eating a huge tray of palaeoart brownies: indulgent, long past being novel or interesting, but it's hard to no enjoy it.

Two of the artworks here do not show the gigantic, robust animal we think of as *Tyrannosaurus rex*. Instead, they show juvenile *Tyrannosaurus*, their appearance being based on skeletons of immature tyrannosaurids. These bear surprisingly different proportions to older individuals. Several tyrannosaurid taxa, including *Tyrannosaurus*, started life as long-legged animals with relatively shallow skulls and gracile bodies. Only in later life did they grow into the more familiar 'massive murder-death-killmachine' bauplan. Interpreting these changes in *Tyrannosaurus* specimens has proved controversial among scientists. Some argue that our half-size *Tyrannosaurus* specimens actually represent a different, diminutive species, *Nanotyrannus lancensis*.

There is a lot of back of forth about the validity of *Nanotyrannus* which we needn't concern ourselves with here: even if *Nanotyrannus* is a genuine taxon and not a juvenile *Tyrannosaurus*, actual immature *Tyrannosaurus* probably looked very similar.

My two illustrations of juvenile *Tyrannosaurus* are whimsical affairs, both showing these mighty carnivores concerning themselves with insects rather than attacking other dinosaurs. The first (opposite) shows two teenage tyrants at rest, one tracking a suite of moths overhead while the other sleeps. This privately commissioned piece required specific colours in these animals, something which could be justified through sexual dimorphism, but in such young animals? Science actually has our back here: like many modern animals, dinosaurs achieved reproductive maturity long before they hit full size. Ergo, it is not unreasonable to assume that differences in gender, such as colouration, might have appeared in relatively small, young animals.

The second image, on page 85, shows younger tyrants accosting a large honey bee hive. These animals are depicted with similar colouration, being of such juvenility that camouflage remains more important than differentiating gender. It might seem strange to place any Mesozoic creature alongside honey bees, but analysis of bee DNA suggests the ancestors of most modern groups - including honey bees - were around by the Late Cretaceous. These findings have not yet been confirmed through fossil remains, but bees have a very poor Mesozoic record which likely only hints at their true diversity. For the time being, calibrations of their evolutionary rates are our best insight into their Mesozoic diversity.

It was fun thinking how dinosaurs might interact with ancient honey bees. Would they attempt to steal honey or grubs from the hive, as attempted by many modern animals? If so, how would fearsome *Tyrannosaurus* handle being swarmed with angry bees? Both these ideas are hinted at in this image, the two small tyrants performing a raid on a bee hive, angering the residents, and the smaller animal not being up to the challenge.

This image could be seen as a low-key awareness campaign about the dangers of having tiny arms when being stung in the face by angry bees.

The remaining images show more traditional depictions of *Tyrannosaurus* as a large, powerful, and sometimes violent animal. 'Violent' is right for the image below, which shows a pairing of tyrants with added constraining neck biting. A number of theropod species are thought to have bitten each other around the face and head, their skulls being riddled with tooth marks and, on occasion, found with broken teeth embedded in cranial bones. The *Tyrannosaurus* specimen widely known as 'Stan' has deep toothmarks and damage around its braincase, indicating these animals did not restrict their biting behaviour to face-to-face confrontations. The back of the head and neck is a common biting point in mating animals, and this painting speculates that some *Tyrannosaurus* cranial injuries resulted from violent nuptial encounters. Slight dimorphism is depicted here, the male being larger than the female and bearing a natty head stripe. It's often speculated that female non-avian theropods

Rough rex: a violent nuptial encounter for *Tyrannosaurus rex*
Late Cretaceous (Maastrichtian), USA. (2013, revised 2016)

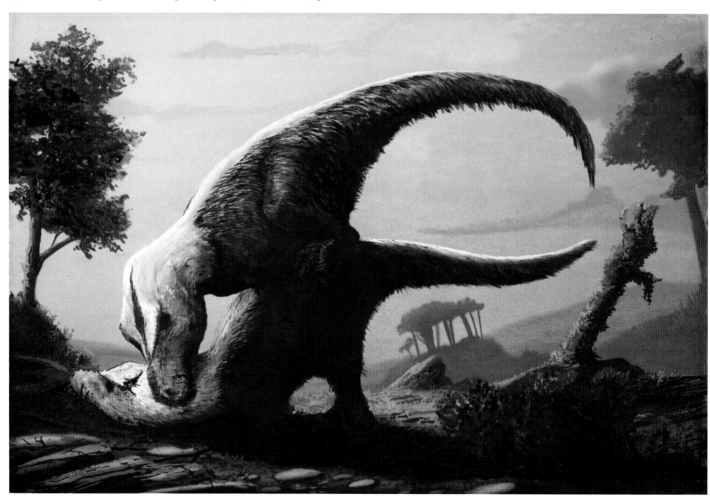

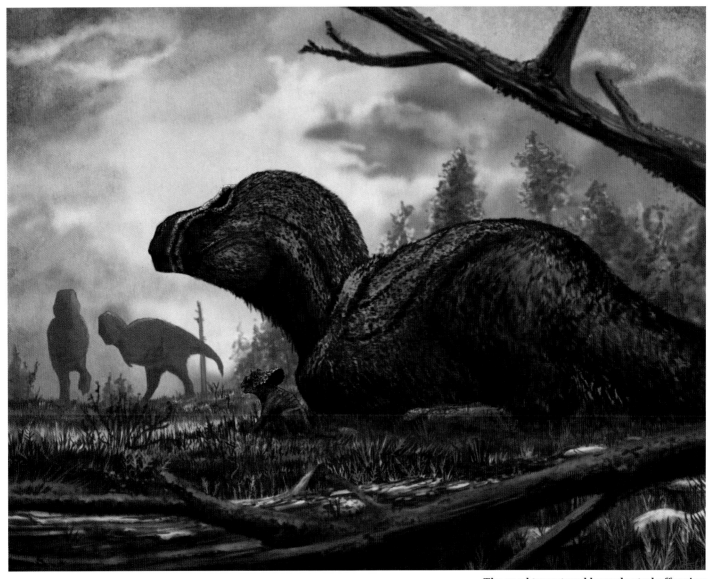

The mad tyrant and her adopted offspring
Late Cretaceous (Maastrichtian), USA. (2015, concept by Chidumebi Browne)

would be larger than males because of the 'reverse' size dimorphism of modern raptorial birds. However, this condition is unusual among other extant archosaurs and, in most dimorphic species, males are larger bodied. Of course, whether *Tyrannosaurus* was dimorphic at all remains unknown.

A quirky take on a 'classic' *Tyrannosaurus* scene is shown above. Virtually since its discovery, *Tyrannosaurus* has been depicted as an enemy of the famous horned dinosaur *Triceratops* (p. 74-75). In this privately commissioned image however, the bizarre phenomenon of inter-species adoption sees the tyrant turn protector of a baby *Triceratops*. Such adoptive scenarios are surprisingly common among modern animals - including living dinosaurs - and it is not unreasonable to assume this behaviour happened in deep time as well. The cause of inter-specific adoption is poorly understood. It might be that parents mistake similar-looking offspring for their own, are confused by the sight of juvenile animals in certain circumstances, or are suffering from a behaviour-altering ailment. The abnormal circumstances of this scene are reflected by the marauding tyrannosaurs in the background of this image. Unlike the foreground tyrant in this piece, their interest in the *Triceratops* juvenile is not amiable.

Overleaf is my favourite image in this set: a large, robust *Tyrannosaurus* strolling around as night falls. There's nothing particularly original about this scene (although it might be the only *Tyrannosaurus* with cranial colours referencing the 2012 movie *Dredd*) but it was a fun picture to paint. This was one of the first images I started after finishing my 2013 book

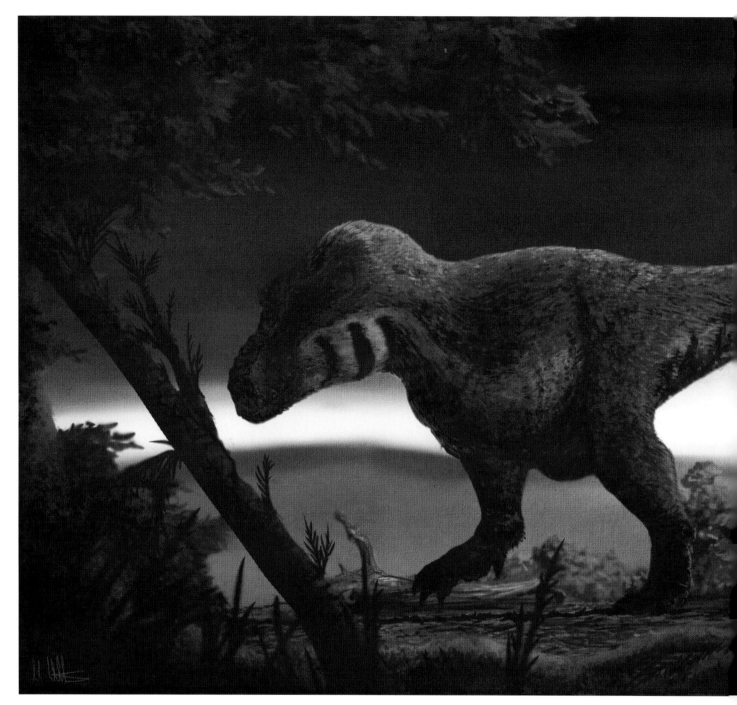

on pterosaurs and I won't pretend that the change of focus wasn't welcome. Perhaps because I wasn't constrained to rendering animals weighing mere grams or kilograms any more, this image shows the biggest, most robust extreme of known *Tyrannosaurus* anatomy. Tyrannosaurs are famous for being relatively nimble and fleet of foot compared to other large theropods, but the biggest of their species were still real heavyweights with massive hips, barrel-shaped chests, enormous necks and powerful heads - nature's compromise between the requirements of a ballerina and a Challenger tank. Doubtless, this combination of agility and strength in tyrant dinosaurs is one reason we keep coming back to them in artwork and popular media - no other predatory dinosaurs fuse size, speed and power quite as perfectly as *Tyrannosaurus*.

A large, robust *Tyrannosaurus rex* on the move
Late Cretaceous (Maastrichtian), USA. (2012, revised 2015)

Those persistent azhdarchid pterosaurs

I owe a lot to azhdarchid pterosaurs, these toothless, often long necked and sometimes gigantic flying reptiles being instrumental to my career and personal life (top tip for chaps: you can discover wives by building models of giant azhdarchids). This means I have a bit of a soft spot for them, the big, pointy-faced, giraffe-sized lugs.

With a lot of my research focused on aspects of azhdarchid palaeobiology - what they ate, how they foraged, how they flew, what they looked like and their diversity - it is unsurprising that my artwork often reflects the findings of these investigations. It must be said that azhdarchids are mostly not represented by high-quality fossils and virtually all of our restorations owe something to the better known species *Quetzalcoatlus* sp. (right) and *Zhejiangopterus linhaiensis*. Azhdarchids thus present a challenge to artists because depicting them accurately, and appreciating the significance of their fossils, is not always easy. One aspect I have frequently battled with is their size and proportions. Azhdarchids have one of the most extreme body plans of any tetrapod and it can take some getting used to, both artistically and scientifically. Their heads are huge, their necks incredibly long and mostly stiffened, but their bodies are tiny - only about 35% as long as their skulls. Their wings have a reduced wing finger but enlarged proximal elements, and the legs are very long. The result is a truly alien bauplan that has catalysed long academic discussions about their lifestyle, body masses and functional potential.

The one thing most people know azhdarchids for is their size. Some of the most famous azhdarchids - *Quetzalcoatlus northropi*, *Arambourgiania philadelphiae* and *Hatzegopteryx thambema* - hold the size record for flying animals with wing spreads being estimated at around 10 m. There are other pterosaur groups which come close to this wingspan, but the long appendages, large necks and oversize heads of azhdarchids mean they likely outweighed these other animals by a great degree, making them the largest flying animals ever. Experts have traditionally thought that these animals (and other large pterosaurs) must be extremely lightweight in order to fly, 10 m wingspan animals

Below: Mid-sized azhdarchid pterosaur, mostly based on *Quetzalcoatlus* sp., in high-altitude flight. (2014, revised 2015)

Opposite: *Quetzalcoatlus* sp. spies dinner Late Cretaceous (Maastrichtian), USA. (2016)

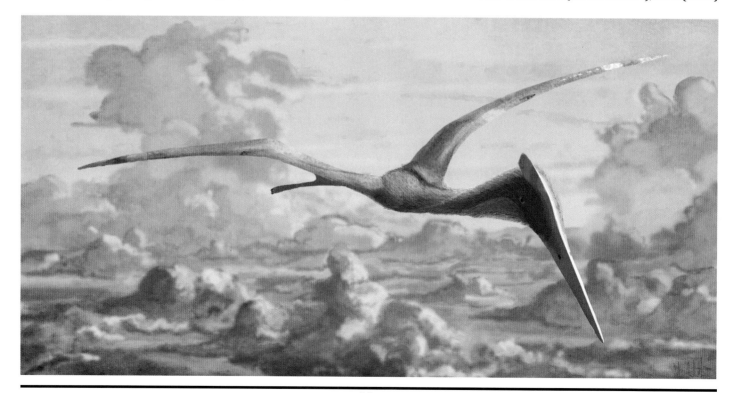

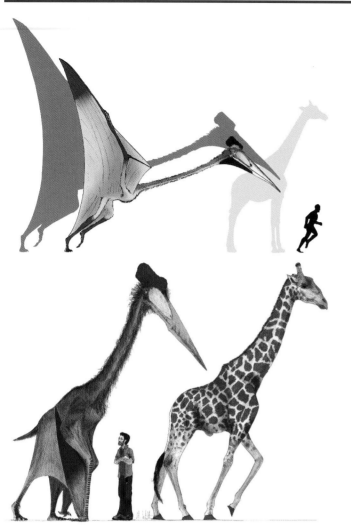
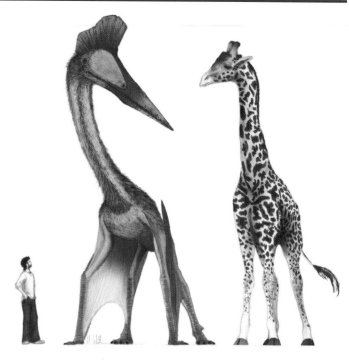

Left and above: The evolution of my giraffe and giant azhdarchid size comparisons. (Top left, 2006; bottom left, 2007; top right, 2008)

Below: Illustration used for press release on the 'terrestrial stalking' azhdarchid foraging hypothesis Late Cretaceous (Maastrichtian), USA. (2008)

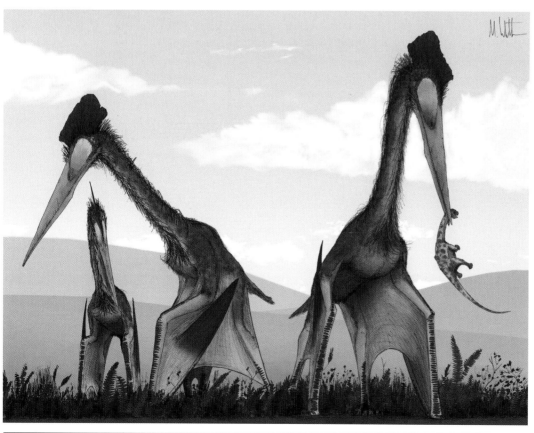

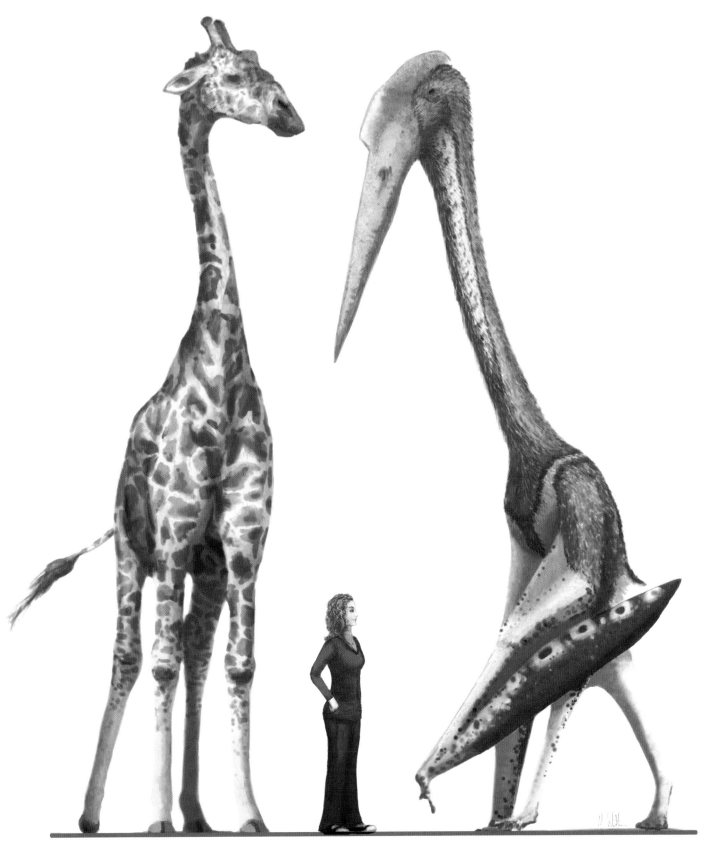

10 m wingspan(?) giant azhdarchid *Arambourgiania philadelphiae* compared to a large bull Maasai giraffe. The Disacknowledgement provides scale.
Late Cretaceous (Maastrichtian), Jordan. (2013, revised 2015)

Previous page: An ex-6 m wingspan azhdarchid is devoured by a suite of Mesozoic predators, including birds, another azhdarchid, and a family of *Saurornitholestes langstoni*. Late Cretaceous (Campanian), Alberta. (2006, revised 2016)

being limited to 70 kg masses. Part of my PhD research involved revisiting this concept, the results being part of a wave of new research arguing for pterosaurs being much heavier than previously thought - about 200-250 kg for the biggest azhdarchids. This is a big increase, but it puts pterosaurs on the same mass-wingspan relationship as modern birds and bats. These new estimates are only 'heavy' compared to historic expectations of pterosaur mass, not real animals.

Exploring pterosaur mass lead to a series of paintings which must be among my best known work: the azhdarchid vs. giraffe comparisons. The earliest attempt at this dates back to 2006 and I've revisited the concept several times since then (p. 92-93). The revised versions were executed to correct mistakes in earlier versions as well as to produce more technically competent versions of the same illustration. The azhdarchid in each picture has changed over time as well. The oldest are *Quetzalcoatlus*, the next was *Hatzegopteryx*, and the final *Arambourgiania*. There are good reasons for this final choice - ongoing research suggests we need to be quite specific with our labels for these giant pterosaurs, and *Arambourgiania* is the only giant known with a neck long enough to challenge a giraffe in height. Also contrary to older interpretations, new research is showing that azhdarchids weren't all alike.

The amount of sharing, copying and discussion received by these images suggests they have been well received, and I expect this is because they demonstrate the proportions of azhdarchids in a context we can readily appreciate. Traditionally, pterosaur size is shown using silhouettes of flying animals next to silhouettes of people. However, our perception of size seems to be distorted by outspread wings. Restoring pterosaurs as standing creatures with folded wings makes their height and bulk more appreciable, and adding the tallest animal of the modern age - which only just exceeds a giant azhdarchid in height - makes it clear that they are enormous all around, not just a giant set of aerofoils. I recall a 2007 conference audience of pterosaur experts gasping and murmuring at the second iteration of this image, and I like to think it's played some role in conveying how massive giant pterosaurs must have been.

Research into azhdarchid lifestyles and foraging techniques are another set of projects I've been involved with. Early in my PhD I found that fellow pterosaur worker and chum Darren Naish had a shared interest in this and, despite disagreement about azhdarchid lifestyles in wider academia, we found a large amount of commonality in our perception of azhdarchid lifestyles. The result was a 2008 paper which combined data from the azhdarchid fossil record, their functional morphology, comparative anatomy, and evaluation of every lifestyle proposed for them. We found that no existing proposals (including skim-feeding, surface gleaning, scavenging, wading and pursuit swimming) really suited our data, so we developed the 'terrestrial stalker' hypothesis. 'Terrestrial stalking' is a really just a cooler way of describing 'just walking around eating whatever they could'. Support for this lifestyle is found in details of azhdarchid limb anatomy, neck function, the skew of their remains to continental deposits, and the similarity of their wing ecomorphology to modern terrestrial birds. Uniquely, our concept does not require much in the way of neck motion, which is a major issue for other hypotheses. As time has gone on, Darren, myself and others have augmented the terrestrial stalking hypothesis with new fossil and biomechanical data.

We wanted art to publicise our 2008 paper because, in the first instance, we thought a lot of people would be interested in it, and in the second, we're basically overgrown children who like pretty pictures. The result was an illustration which seems to have started something of a meme: *Quetzalcoatlus northropi* eating a baby titanosaur (p. 92). Despite the range of prey items azhdarchids likely ate (we think they were generalist feeders, with the giants focusing most on small vertebrate prey, p. 98-99), a number of books, toys and even documentaries now specifically show sauropods as the food of giant azhdarchids - we may have created a monster there.

Speaking of monsters, our interpretation of terrestrial stalking took a left turn with discoveries about the likely nature of one giant pterosaur species, *Hatzegopteryx thambema*. Ongoing research by myself and colleagues show this animal is quite different to other azhdarchids. Always noted for its solidly built bones, recovery of more material of this Romanian animal suggests it was robust overall with a wide skull, chunky lower jaw, robust limbs and - for an azhdarchid - a short neck. Multiplying these features across our terrestrial stalker

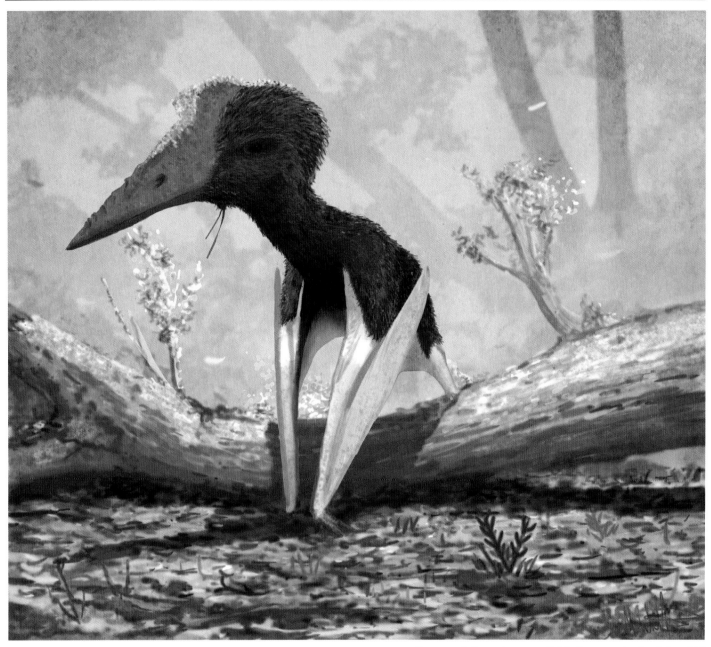

**Unnamed, 3 m wingspan(ish) short-necked azhdarchid
Late Cretaceous (Maastrichtian), Romania. (2015)**

hypothesis suggests that this pterosaur might've been a real bruiser, an azhdarchid capable of subduing and swallowing even man-sized prey. This animal is part of the famous Hațeg island biota - a Late Cretaceous 'island fauna' comprising unusually small and archaic lineages mostly separated from mainline evolution at that time. We note it is the largest predator currently known in that setting and suspect that *Hatzegopteryx* was an arch predator of this environment (p. 100-101). That a pterosaur may have been top of the food chain in a terrestrial Mesozoic ecosystem is a radical proposal, likely unthinkable a few decades ago. That such ideas aren't laughed out of the room shows how much our perception of pterosaurs has changed in recent years.

Our understanding of azhdarchids continues to develop rapidly. Shortly after calculating a short neck length estimate for *Hatzegopteryx*, my colleagues and I realised another azhdarchid neck vertebra might indicate a similar morphology in another, much smaller animal. This animal, too poorly known to name, became the focus of another paper and painting (above). Odd as it seems to see that big head on a short neck, I'm sure we're going to see much more weirdness in our art as we slowly learn more about this widespread and important group of pterosaurs.

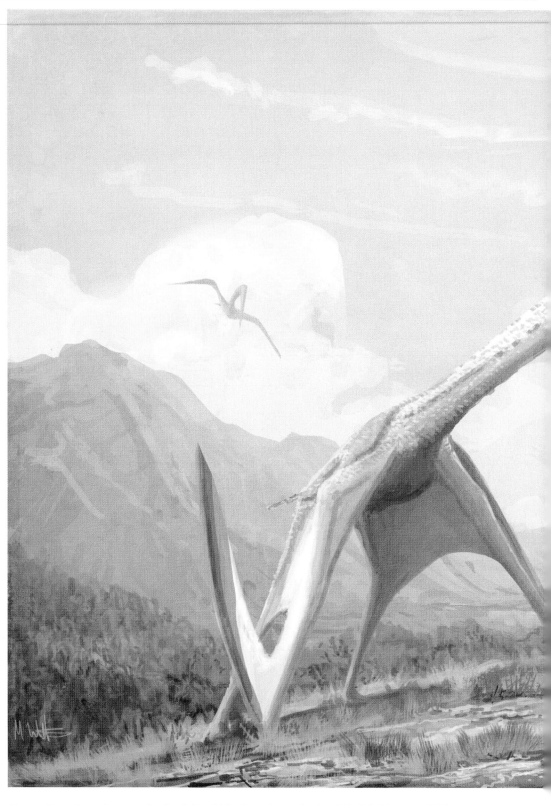

Above: Two giant, long-necked azhdarchids *Arambourgiania philadelphiae* squabble over a troodontid meal
Late Cretaceous (Maastrichtian), Romania. (2015)

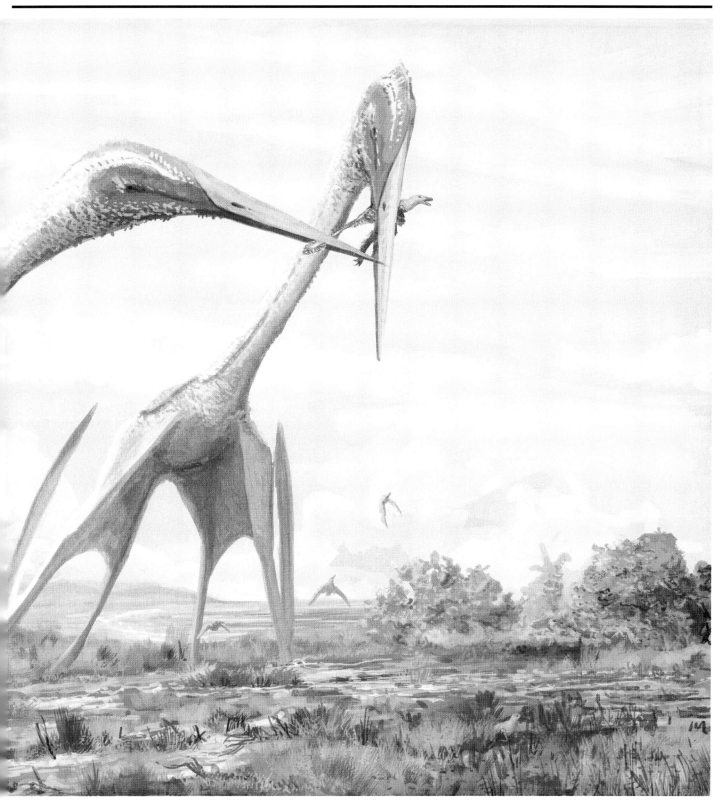

Overleaf: Iguanodont *Zalmoxes robustus* at the start of its terrifying assimilation into the body of the winged, apocalyptic terror that was the short-necked giant azhdarchid, *Hatzegopteryx thambema*
Late Cretaceous (Maastrichtian), Romania. (2014, revised 2016)

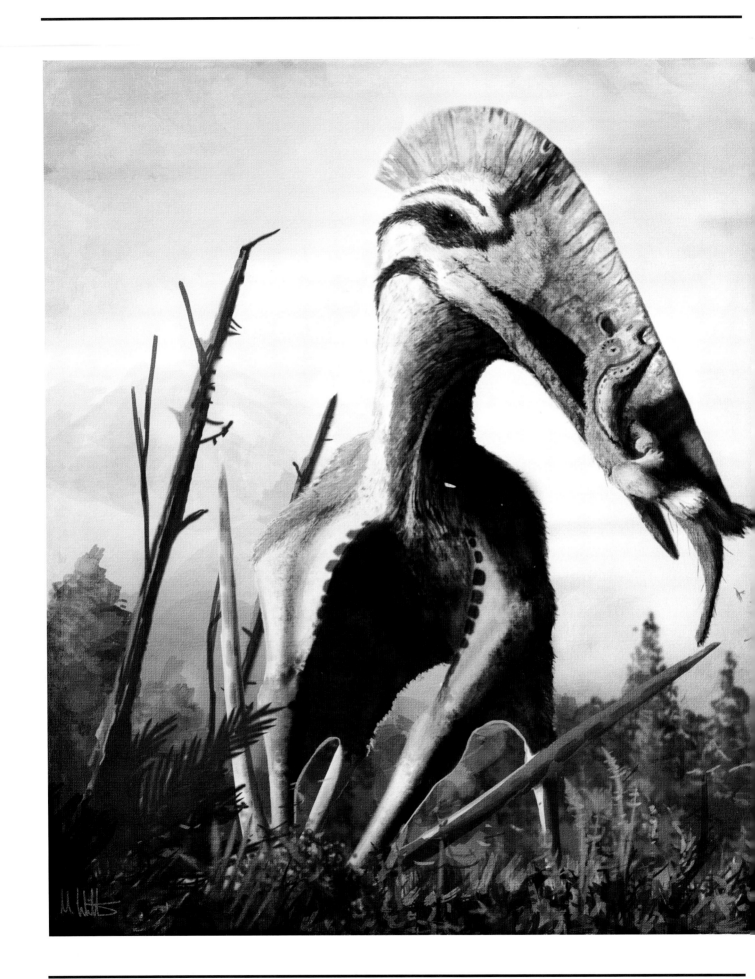

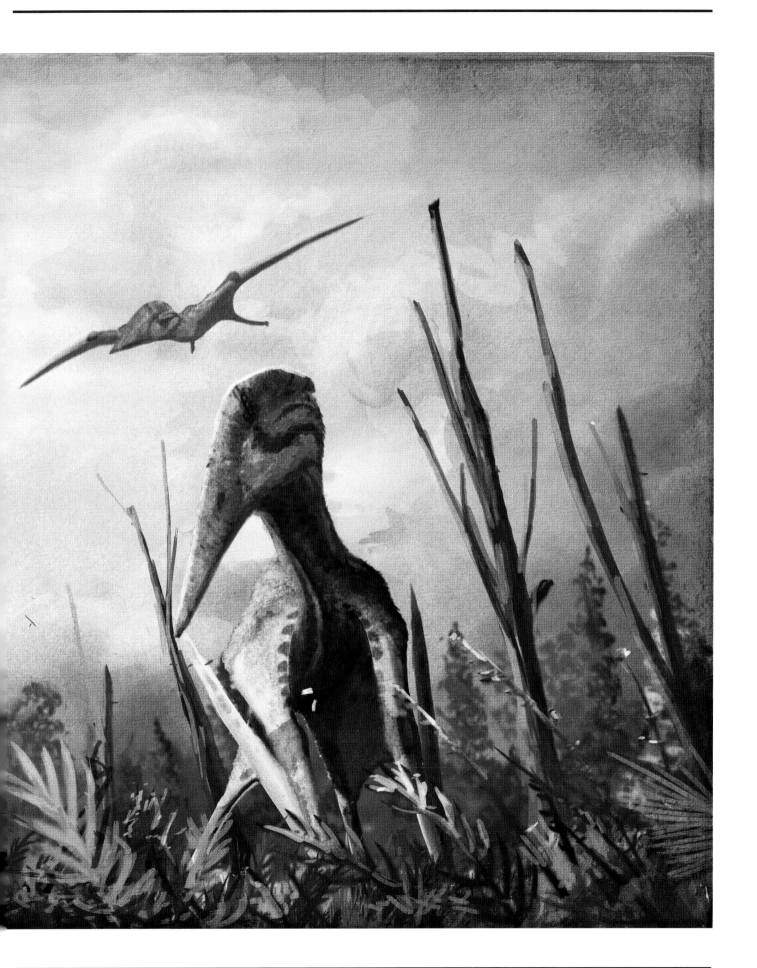

Postscript: All those moments will be lost in time

Palaeoartworks are typically scrutinised from two angles: artistic merit, and their 'accuracy'. By the latter, we mean how tightly they adhere to contemporary scientific thinking on their subject matter. Are the proportions of reconstructed animals correct? Have they been given soft-tissues concordant with fossil data? Are their behaviours and poses consistent with our understanding of biomechanics and palaeoecology? And is the environment, flora, and contemporary fauna appropriate in light of their local palaeontology, sedimentology, palaeobotany, and so on? This quest for accuracy has led to some palaeoartists arguing that we need a certain amount of data before a reconstruction of a given subject can be attempted. This seems logical: how can we feel we've reconstructed an organism even partly accurately from anything less than a good chunk of fossil data?

However, in reality, nothing we do in palaeoart can be considered 'accurate'. The fossil record does not permit a precise knowledge of life millions of years ago, only relatively coarse, ever-changing glimpses of previous epochs in which little is 100% certain. Even the best known fossil organisms are only loosely sketched by palaeontological science: their appearance, position in extinct ecosystems and relationships to other species can be generally deduced, but hard facts on even basic parameters such as animal size, their precise diet, and sometimes even where and when they lived, can be difficult to establish. This occurs despite increasing vigour in palaeontological science. Even our best, most thoroughly tested data is often too incomplete and biased to rule out some doubt on most topics. As alluded to in the opening to this book, palaeontological theory is full of contested ideas about even well-known fossil species, and multiple, equally valid interpretations of fossil data can coexist.

Time has shown that even reconstructions based on relatively sound datasets – such as complete fossil skeletons – can be superseded at any time. New means of analysing fossil data can turn what we once thought were sound hypotheses on their head. For example, the shake up of vertebrate evolutionary relationships that accompanied the development of phylogenetic analyses in the 1980s and 1990s dated a lot of artwork, as knowing evolutionary relationships is integral to our reconstruction process. A breakthrough in understanding anatomy - such as the realisation that dinosaur tails should be elevated and strongly muscled- has the same effect, as will simply finding fossils that fill previous gaps in knowledge.

Faced with these issues, our quest for 'accuracy' becomes a problem. To know that our work is truly accurate we need some means to test our reconstruction against bona fide truths of ancient animals. But this is impossible: how can we know if we have – by luck or skill – reconstructed a species precisely when so much information is missing from the fossil record, and will likely always be missing? We can, of course, test some elements of palaeoartworks. Basic proportions, some aspects of muscle structure, and perhaps associated biota are fairly objective elements of any reconstruction, as is the incorporation of non-skeletal tissues known from subject taxa. But most data required to completely restore an extinct organism rarely survives fossilisation and exhumation. Even fossil Lagerstätten – those sites preserving fossils of exceptional quality and/or abundance – do not preserve such detail. Any reconstruction of a fossil animal relies on assumptions and extrapolations of data beyond that permissible in a strictly scientific endeavour. Good palaeoartists are as scientific and rational as they can be, but we should not pretend that palaeoart is a truly scientific game.

I've come to think that what palaeoartists really seek is not scientific accuracy, but *credibility*. This might seem like pedantry, but admitting our work can never be 'accurate', and only 'credible', permits a shift in approach to palaeoart projects. There's less need to conform to expectations or worries about the longevity of a reconstruction, and more impetus to explore contemporary hypotheses for alternative, but equally scientifically valid takes on fossil life. It means that we're not worried about 'playing it safe' with better known subjects and can visit parts of the fossil record we understand less completely. Acknowledging that our work will only ever be a snapshot of contemporary thinking is a great motivator for finding interesting palaeoart topics.

This line of thinking can be boiled down to four major points. Firstly, we might want to abandon the idea that only relatively completely known taxa should feature in 'credible' artwork. Provided enough information is apparent to determine the relationships of a species to other animals, we can normally deduce something of its characteristics even when only fractions of their skeletons are known. Unusual limb proportions, a robust or gracile construction, atypical body size and so on can be conveyed from carefully studied fragmentary fossils. Palaeontologists remark on this sort of thing frequently, descriptive papers being full of remarks such as "this animal was a particularly robust member of its lineage" or "this species was likely small-bodied and long-necked compared to its relatives". These fossils can represent some extremely interesting and distinctive species, and we can speculate how they may have looked by combining their actual anatomy, the morphological implications of their known features, and general form of better known relatives to produce tentative restorations of them. There are obviously limits to how far we can take this – some

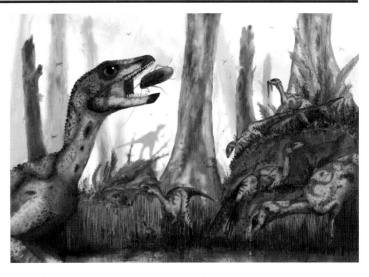

Above: Press release image for the description and naming of *Laquintasaura venezuelae*. Scales abound.
Early Jurassic (Hettangian), Venezuela. (2011)

Below: 2015 remix of the *Laquintasaura* PR image, with the skin of *Laquintasaura* now bearing a mix of scales and filaments
Early Jurassic (Hettangian), Venezuela. (2015)

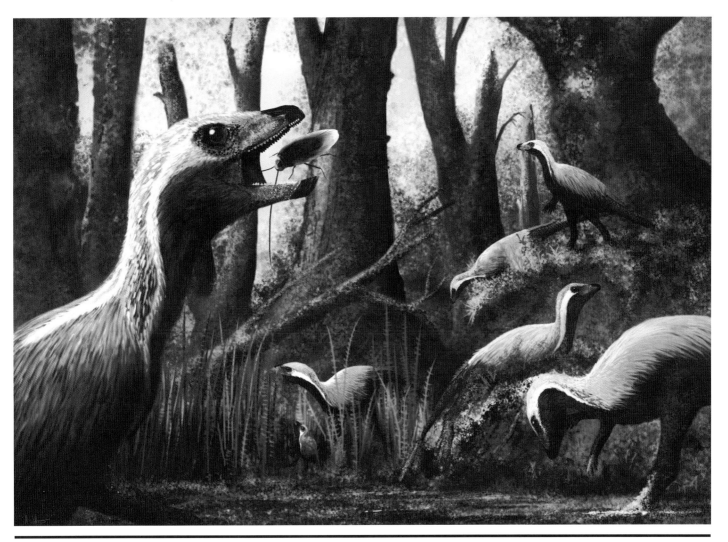

species really are too poorly known to attempt even a tentative reconstruction. But so long as the remains are sufficient to show something distinguishing about the subject species which can be translated to art, there is some value in tackling it as a palaeoart subject. An example of this approach can be seen on page 34, where the giant dromaeosaur *Achillobator* - known only from pelvic remains, scraps of limb and some snout material - is restored as big, powerful but rather lumbering dromaeosaur. The reconstruction is largely speculative, but is true to the anatomy and morphological character of its fossils. The value here is demonstrating that not all dromaeosaurs were clones of *Velociraptor* or *Deinonychus*.

Secondly, we should encompass the variation within groups when reconstructing anatomical gaps in subject species. We alluded to this on pages 96 and 97 when discussing recent discoveries showing that azhdarchid pterosaurs were not just variations on *Quetzalcoatlus* sp. and *Zhejiangopterus linhaiensis*. We have good, albeit fragmentary, evidence that different body plans were present in this group, and we should not be reconstructing poorly known azhdarchids as simply clones of the best known species. Similarly, north African spinosaurine theropods should now be considered open to a lot of anatomical interpretation. Fragmentary material unearthed in the last few years has famously (and controversially) sparked radical discussion about the life appearance of these animals. Suddenly, artists have scope to draw *Spinosaurus* and its kin in ways hitherto thought infeasible - short hindlimbs with four large toes, a sail extending over the entire back and so on. It's unclear how accurate our restorations of these animals are, but they are all equally credible, given current knowledge.

A third concept is reconstructing ancient biotas

A 'classic' restoration of the theropod *Spinosaurus aegyptiacus*, an illustration at odds with some current interpretations of spinosaurine theropods (opposite)
Late Cretaceous (Cenomanian), Egypt. (2014, revised 2015)

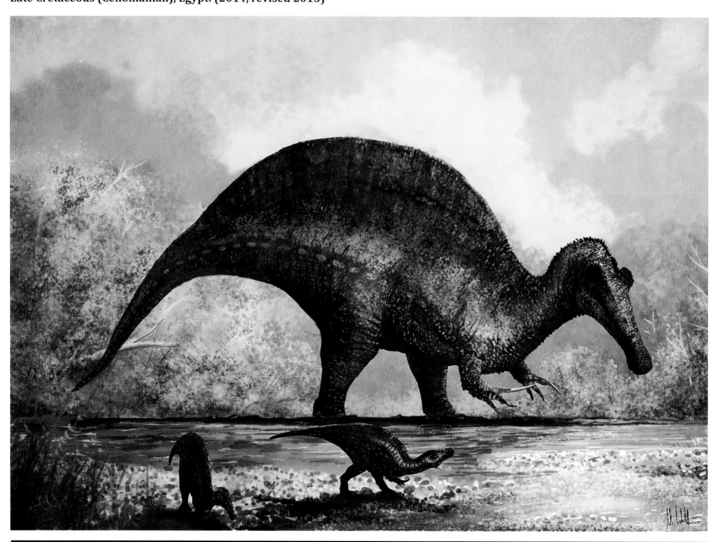

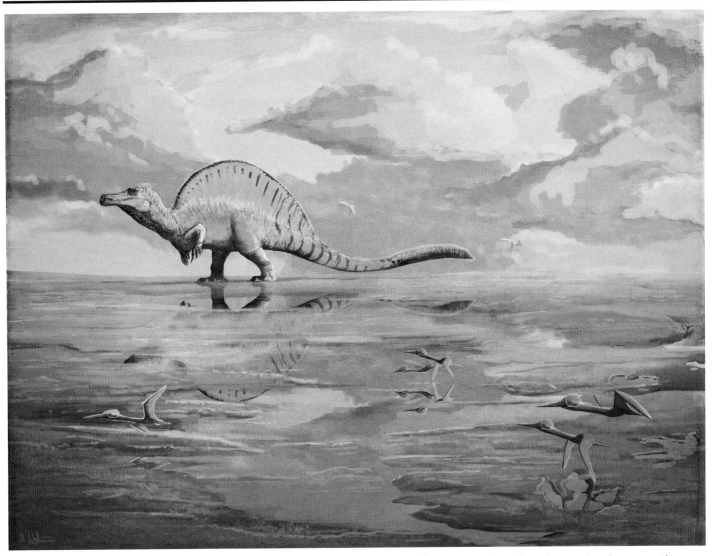

A modern restoration of a spinosaurine, incorporating new proposals of reduced hindlimb proportions, functionally tetradactyl feet and aquatic adaptations Late Cretaceous (Cenomanian), north Africa. (2016)

which are represented solely by poorly known taxa. A lot of ancient ecosystems are overlooked in art because the fossils representing their fauna and flora are very fragmentary, even though their biota might be remarkable for representing a distinctive mix of species or having historical significance. We can produce a representation of that biota through the approaches outlined above, producing artwork which is characterised by distinctive mixes of animals and environments rather than the individual components themselves. Of course, this approach leans heavily on the anatomy of the better known species related to those in our subject biota, and the resultant artworks have limited value as individual animal profiles. But when depicted together that selection of species can provide a visual overview of these ancient faunas, and give a flavour of how we currently understand life from these lesser represented parts of history. This is something I attempted for the Lower Cretaceous Hastings Beds, on pages 66-67: I don't doubt the image will be superseded when new information about the Hastings Bed fauna is found, but I'm happy to have recorded our understanding, circa 2015, of these animals in art.

The fourth point is to embrace new, compelling data even when it contradicts older, established ideas. So long as there is good reason to trust a new interpretation, we shouldn't be worried about depicting it just because it seems odd in light of our more familiar approaches. Fuzzy hides and quadrupedal launch in pterosaurs, the weirdly shaped scales of *Triceratops* and bulging caudofemoralis muscles in fossil archosaurs are just some examples of topics which have taken a long time to enter popular usage among artists, and yet all are based on very compelling lines of evidence. As with

Above and opposite: *Megalosaurus bucklandii* (above) and *'Iguanodon anglicus'* as depicted circa 1854. Though terribly dated scientifically now, these old styles of restoration have tremendous historic and cultural value. The fact palaeoart dates is a feature, not a bug, of the trade. (Above, 2016; opposite, 2014, revised 2016.)

good scientists, we artists need to move with the times and not be concerned about depicting unusual ideas simply because they're novel and unfamiliar.

The common element to these points is that there is a lot more information out there than our palaeoart might currently reflect. Embracing these data – even the contradictory nature of some of it – can only improve the novelty, interest and pedagogic utility of palaeoart and will not diminish its scientific integrity. We should be mindful that people learn a great deal about the past through our artwork, and make efforts to utilise our full scope of knowledge, not only the favoured, most familiar or 'coolest' parts of it. We should be mindful that depicting different, but equally credible ideas in palaeoart is a powerful method to demonstrate the non-linear development of scientific hypotheses to lay audiences. This is often a challenging concept to convey in outreach, but palaeoart does it very well, and we should embrace that as educators.

For a lot of our artwork, a time will come when it is no longer scientifically credible. This is something most of us dislike the idea of. It's as if our outdated work has somehow failed and become an embarrassment - there's work out there with our names on it that is no longer up-to-date, oh no! But this is not a reason to play it safe. The fact that our art often dates is a *feature* of our trade, not a problem. We get to 'own' what our science said when we recorded it, and that adds character to our work that other generations can't have, because their science will be different. Our palaeoart is a visual record of our changing understanding of Deep Time and the evolution of life, and an illustration of the scientific method at work. It allows us to not only look back on the flaws of previous ideas but to also witness the seeds of developing theories, and thus see how far we've come. So ultimately, the more we embrace the science of our own time, the more worth our artwork has *because* it dates. Our challenge as artists is not to make 'accurate' work, but to record our perception of the past for the next generation to appreciate and learn from, whether it stands the test of time or not.

Index

A
Achillobator 104
Achillobator giganticus 34, *34*
albanerpetonids 30
All Yesterdays 8, 76
Allosaurus fragilis 10,*11*
ammonites 20-1
Anteophthalmosuchus hooleyi 57, 58
Anurognathus ammoni 39, 40, 42
Arambourgiania philadelphiae 90, 92-3, 96, 98-9
Aucasaurus garidoi 10, *14*
azhdarchids 65, *66-7*, 90-101

B
Bakker, Robert 28
Barilium dawsoni 62, *63*, 64
Baronyx walkeri 60, *60-1*
Becklespinax altispinax 65, *66-7*
Bennett, Christopher 20, 42
Billy and the Cloneosaurus 8
Brontosaurus excelsus 27-8, *28*
Burian, Zdenek 9

C
Camarasaurus supremus 25-6, *26*
Caviramus schesaplanensis 41, 42
ceratopsians 68-76
Chroicocephalus ridibundus (Black-headed gull) 25
Citipati osmolskae 10, *11*
coelids 21
Conway, John 8, 76
crocodyliformes 31, 56, 58
Cuspicephalus scarfi 36, *36*

D
Deinonychus antirrhopus 10, *15*
Deinosuchus robusutus 58, *58-9*
Delgado, Ricardo 7

Dimorphodon macronyx 50-1, *50-5*
Diplodocus carnegii 27, *27*
Dorygnathus banthensis 42, *42*
Drepanosaurus unguicaudatus 78, 80-2
dryosaurids 65

E
Engh, Brian 27
Eotyrannus lengi 9, *10*
Erymnoceras coronatum 20, *20-1*

G
goniopholidids 60, *61*
griffin 76

H
Habib, Mike 42
Haestasaurus becklesii 65, *66-7*
Hastings Beds fauna 65, 105
Hatzegopteryx thambema 90, 96-7, *100-1*
Henderson, Donald 43
Hone, David 43
Hulkepholis willetti 31-2, *31*
Hylaeochelys belli 65, *66-7*
Hypsilophodon foxii 57, 58

I
Iguanodon anglicus 107
Iguanodon bernisssartensis 62-4, *62*
inter-species adoption 87

J
Jurassic Park (film) 7

K
Kayentachelys aprix 46
Kayentatherium wellesi 46, 47-8
Knight, Charles 9, 28, 76
Koseman, Memo 8
Koumpiodontosuchus aprosdokiti 58, *59*

L
Laquintasaura venezuelae 103
leptocleidids 56
Leptocleidus superstes 56
Longisquama insignis 82, *83*
Lund, Eric 76

M
Machairoceratops cronusi 72-3, *76*
Mamenchisaurus youngi 24-5, *24*
Megalosaurus bucklandii 106
Morganucodon watsoni 49, *49*

N
Naish, Darren 8, 26, 27, 96
Nanotyrannus lancensis 85
Neovenator Salerii 9, *13*
Nicholls, Bob 18

O
O'Connor, Pat 76
Ophthalmosaurus icenicus 18, *18*
Opisthias rarus 10, *11*
Ornithocheirus simus 35 *36*
ornithomimosaurs 64, *64*
Oryctodromeus cubicularis 32, *32-3*
Ouranosaurus 26

P
Pachyrhinosaurus perotorum 70-1, *76*
Paul, Gregory S 7, 8, 72
Predatory Dinosaurs of the World 9
Peabody Museum, Yale 27
Pelosaurus conybeari 25, *25*
Protoceratops 73, 76
hellenikorhinus 69, *73*
Pteranodon sternbergi 19, 20
Pterodactylus antiquuus 44-5, *44-5*

Q
Quetzalcoatlus 90, *90, 91*, 96
Northropi 92, 96

R
rebbachisaurids 9, *12-13*
Repenomamus giganticus 48, *49*
Rhamphorrhynchus muensteri 43, *43*
Russell, Dale 7

S
Sarcosaurus woodi 50
sauropods 24-8
Saurornitholestes langstoni 94-5
Scleromochlus 77, 80
 taylori 77, *77*
Sharovipteryx mirabilis 79, 82
Sinornithoides youngi 16, *17*
Sordes pilosus 36-8, *37*
spinosaurids 60
Spinosaurines 26, 104, *105*
 aegypticus 104
Stereognathus ooliticus 47, 48
Styracosaurus albertensis 68
Sweetman, Steve 31

T
Tanystropheus longobardicus 79, *80-1*, 82
Taylor, Mike 26, 27
Therizinosaurus cheloniformis 12, *16*
theropods 9
Torvosaurus tanneri 9, *9*
Triceratops horridus 74-5, 76, 87
Troodon formosus 21, *22-3*
Tuatara 10
Tupandactylus navigans 38, *39*
Tusoteuthis longa 21
Tyrannosaurus rex 84-9, *84-9*

U
UK, Early Cretaceous 62-7

V
Valdosaurus canaliculatus 64, *65*
'vampire squid' 21, *22-3*
Varner, Dan 18
Velociraptor mongoliensis 10, *11*

W
Walking with Dinosaurs (TV programme) 26
Wesel, Mike 26, 27
Wesserpeton evansae 30-1, *30*
Willoughby, Emily 64

Z
Zallinger, Rudolph 27
Zalmoxes robustus 100-1